IMAGES
of America

FIGAWI RACE
HYANNIS TO NANTUCKET

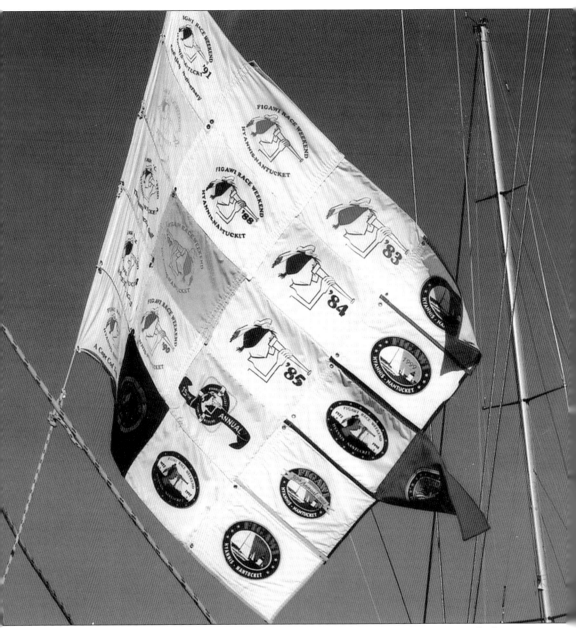

COMING BACK EVERY YEAR. Each year at the Friday night orientation meeting, each skipper is presented with a Figawi pennant, which identifies his or her boat as being "in the race" that year. These pennants become collectors' items and, flown together, they indicate the owner's years of participation in the race. Here is a boat owner's collection of 21 pennants hoisted from the flag halyard at the Nantucket docks. (Courtesy of Ed O'Neill.)

ON THE COVER: SAILING IN. After crossing the finish line, some of the Figawi fleet ease their way around Brant Point Light and are heading into Nantucket to tie up at the boat basin. (Courtesy of Arnold Miller and the *Cape Cod Times*.)

Joe Hoffman

ARCADIA
PUBLISHING

Copyright © 2013 by Joe Hoffman
ISBN 978-0-7385-9917-5

Published by Arcadia Publishing
Charleston, South Carolina

Printed in the United States of America

Library of Congress Control Number: 2012952827

For all general information, please contact Arcadia Publishing:
Telephone 843-853-2070
Fax 843-853-0044
E-mail sales@arcadiapublishing.com
For customer service and orders:
Toll-Free 1-888-313-2665

Visit us on the Internet at www.arcadiapublishing.com

This book is dedicated to the love of my life, Felicia Penn.

Contents

Acknowledgments		6
Introduction		7
1.	The Early Years	9
2.	Figawi Boats	19
3.	Sunday on Nantucket	59
4.	Joke-Telling Session	67
5.	Winners and Awards	73
6.	Figawi Charity Ball	85
7.	Friends of Figawi	95
8.	Program Book and Other Treasures	109
9.	Figawi Remembers	117

Acknowledgments

This book would not have been possible without the help of all of the following people. Therefore, I would like to thank J. David Crawford, Leo Fein, Shelley McCabe, Charles McLaughlin, Jacquie Newson, Judy Notz, Patti Nurse, Blake Jackson, Ed O'Neill, John Osmond, Tony Prizzi, Bill Thauer, Dick Vecchione, and Britt Crosby, from the Figawi Race.

I would also like to thank the staff at the *Cape Cod Times*, especially Bill Higgins, Steve Heaslip, John Leaning, Al Belanich, Jeff Bernard, David Churbuck, Geoff Converse, Rob Duca, Terry Pommett, Jim Preston, Kevin Wisniewski, and Vince DeWitt.

Allow me to remember some of those who are no longer with us: Richard Anderson, Fred Boden, Jeffrey Foster, Ed "Sully" Sullivan, Ed O'Neill, and a very special friend who passed away in 2012, Howard Penn.

Most of all, I want to acknowledge and thank Dick Teimer and his Time Capsule archiving studio. This book would not have made it to the publisher if not for the counsel, expertise, and dedication of Dick Teimer, as we collaborated to get this Figawi project completed. Dick's devotion to the idea of producing the very best book possible about the Figawi Race to Nantucket was unwavering and allowed us to realize our goal.

And of course, to my wife, Felicia Penn, goes not only my thanks but all of my love for her support during the months of preparing and writing this book.

—Joe Hoffman
March 18, 2013

INTRODUCTION

It has been 40-some years now since Bob "Moose" Horan and his brother Joe, along with Bob "Red" Luby, thought that racing their boats to Nantucket would be a good way to spend Memorial Day weekend. Therefore, with wives and a few friends aboard as crew, the three sailors set out from Hyannis to see who had the fastest boat to the island. That race would be the first of the Figawi Race Weekends and the beginning of what has become a Cape Cod tradition.

When the three boats arrived at Nantucket, the boat basin was closed. Needless to say, no one was on hand to welcome the winner. In those days, large sailboats were not common, and Memorial Day weekend was not a big holiday on the island. Nantucket Harbor was virtually empty.

The first Figawi awards party, in the race's second year, was held at Cap'n Tobey's in Nantucket. The Figawi Committee, which, at that time, included Bob and Joe Horan, Howard Penn, and Luby, booked a room for 125 people. They had no idea, in 1973, as to what this sailboat race would eventually become.

Figawi soon began to grow by leaps and bounds. A lay day was inserted in 1979 as the race committee, now formally organized, turned the Figawi into a three-day affair. The welcome party was expanded to accommodate the fast-growing fleet, the Carl Flipp Clambake was added to Sunday afternoon, and Nantucket Stardust provided the party atmosphere for Sunday night under the brand new Figawi Tent.

In 1987, the Figawi Board of Governors introduced the inaugural Figawi Charity Ball, a black-tie affair that gave many people on the Cape a chance to be a part of the Figawi experience and, along the way, to raise a lot of money for Cape Cod charities.

A lot of people have contributed to make Figawi what it is today. Some of the skippers who deserve acknowledgment for their support over these many years include John Osmond, Buzzy Schofield, John Griffin, Barry Sturgis, Bob Labdon, Chuck Howard, Charles Prefontaine, Neil Tomkinson, Bob Cicchetti, Ian McNeice, and Bob Warren. Where would Figawi be today without organizers like Tony Prizzi, Charlie McLaughlin, Howard Penn, Dennis Sullivan, Milton Salazar, Jacquie Newson, Leo Fein, Donna Nightingale, and David Crawford, just to name a very few?

The most important thing about the Figawi Race is that it has endured. By design, it is "a fun race to Nantucket" and it is great sport. With this book, we hope to expose you to a true Cape Cod sailing experience. In the end, we hope you will come to know and appreciate the Figawi Race to Nantucket for what it is and what it has meant to so many of us who love the sailing tradition.

One
THE EARLY YEARS

Bob "Red" Luby, along with brothers Bob and Joe Horan, raced to Nantucket on Memorial Day in 1972, and they had a wager among them as to who would get to the island first. Bob Horan said later, "Joe got off to a fast start and tried to run Red up onto the rocks over near Baxter's Boathouse Club. But Red had the faster boat and sailed a helluva race."

Luby commented, "Nobody had anybody onboard who knew how to sail a boat, but it was a lot of laughs." In fact, when Luby went below deck at one point in the race to visit the head, his crew did an about-face and headed in the opposite direction. That sense of misdirection may have led to the naming of the race.

"Where the f*&$ are we?" in Boston or on Cape Cod would sound like, "Where the Fuh-KAH-wee?," which, when cleaned up for sports editor Ed Sullivan at the *Cape Cod Times*, became "Where the Figawi?"

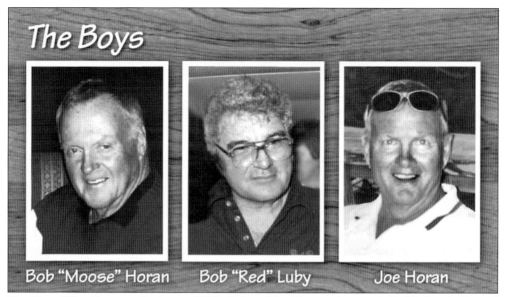

THE BOYS WHO STARTED IT ALL IN 1972. Bob and Joe Horan, along with Red Luby, challenged each other to see who had the fastest boat to Nantucket. Luby won that race, but Bob Horan kept the Figawi going and growing over the next 40 years. Each year, about 225 sailboats rerun that first race and sail to Nantucket on Memorial Day in May. (Courtesy of the Figawi Archives.)

BOB HORAN AND BOB CUNNINGHAM, 1974. On the right, Bob Horan, who founded and promoted the Figawi Race in the early years, is pictured here with his friend Bob "Fat Fox" Cunningham on the streets of Nantucket in 1974. As the story goes, Cunningham—sailing with Horan on a 42-foot ketch named *Caribou*—grabbed a runaway spinnaker sheet and, when the sail filled, he found himself flying way out over the water hanging on for dear life! When the boat leaned his way, he was dunked into the ocean and then quickly back into the air, never letting go of the line. Finally, when Horan tacked the boat just enough, the spinnaker sail dropped Cunningham onto the deck below. (Courtesy of the Figawi Archives.)

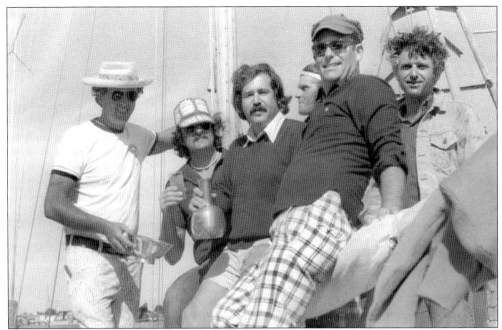

OSMOND AND *THORFINN*, 1975. A victory celebration is underway on the deck at Baxter's after John Osmond and the crew onboard *Thorfinn* won the Division A first-place trophy in 1975. From left to right are Warren "Barney" Baxter (owner of the Boathouse Club), Ted Houghton, John Osmond (owner of *Thorfinn*), Dana Winroth, Stanley Moore, and an unidentified friend of John Osmond. Osmond is drinking from the pewter wine decanter—the original Figawi trophy—which is on permanent display at Baxter's. (Courtesy of the Figawi Archives.)

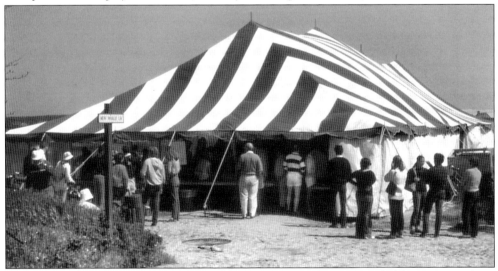

FIRST FIGAWI TENT, 1979. In 1973, the Figawi party after the race was held at Cap'n Tobey's restaurant, a short walk from the docks in Nantucket. By 1977, it had been moved to The Loft in the Nantucket Boat Basin. Pictured here is the first tent, erected in 1979, which covered about 4,000 square feet. It was pitched at the end of New Whale Lane, near the boat basin. In more recent times, the Figawi has been using three tents that total about 15,000 square feet. (Courtesy of the Figawi Archives.)

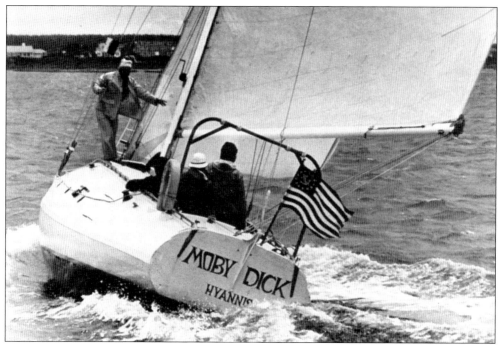

A MOBY DICK MOMENT, 1973. Certainly the weirdest boat to ever sail in this race was *Moby Dick*, the winner in 1973. Stan Moore sailed the needle-nosed or torpedo look-alike boat for owner Ron Cameron, a bartender at Baxter's. (Courtesy of Al Cotoia.)

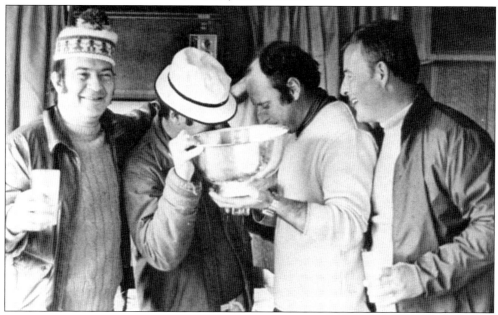

CREW OF MOBY DICK, 1973. From left to right are Al Cotoia, Capt. Stan Moore, owner Ron Cameron, and Jerry Day. According to Al Cotoia, "The awards party in Year Two was held upstairs at Cap'n Tobey's Restaurant in Nantucket. The prize for that race was a Revere Bowl, which was filled three or four times with Black Russians. It was a memorable event." (Courtesy of Al Cotoia.)

"HOWIE FIGAWI" AT THE MICROPHONE, 1980. It seems like Howard Penn has been known as "Howie Figawi" forever. When Bob Horan wanted to expand the three-boat race in 1972 and grow the event into an annual race, he went to Howard Penn. Howard would spend the next 40 years of his life promoting Figawi. It was not hard for Howard to do that. He knew almost everyone on Cape Cod; he certainly enjoyed being on the water and powering over to Nantucket; lastly, he loved the very idea of "selling" the Figawi Race Weekend on the island. (Courtesy of the Figawi Archives.)

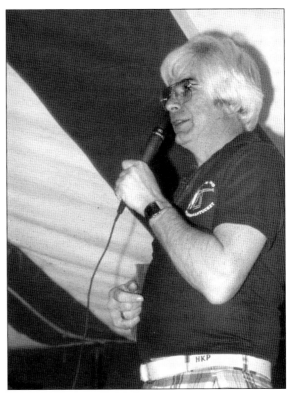

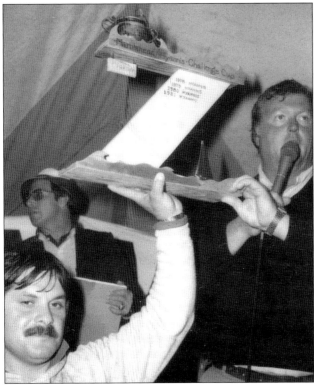

MARBLEHEAD/HYANNIS CHALLENGE CUP, 1982. The following is a conversation between Marblehead's Jeff Foster and his brother Win Carter: Win: "You have to bring your sailboat *Anduril* to Figawi." Jeff: "Who or what is Figawi?" Win: "It's kind of hard to explain." Jeff: "Try me." Win: "You race to Nantucket over the Memorial Day weekend. It's a lot of fun and you can drink all you want." That conversation sealed the deal, and Jeff Foster came to the Figawi Race for many years, bringing with him dozens of boats from Marblehead. He also created the Marblehead/Hyannis Challenge Cup trophy, shown here hoisted by Milton Salazar. Presenting the trophy in 1982 is Bob Horan with the microphone. (Courtesy of Figawi Archives.)

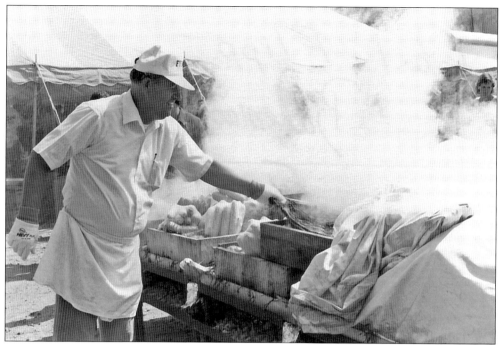

FIGAWI'S FIRST AND BEST BAKEMASTER, 1982. In 1979, the Figawi Committee decided to go to a three-day schedule for the event and added a clambake that would take place Sunday afternoon on the lay day. Bob Horan invited Carl Flipp, owner of Leighton's Catering, to come to Nantucket from his commissary in Kingston, Massachusetts, and bring with him a complete New England clambake. Here is Carl watching over a clambake that, year after year, would feed over 1,000 hungry sailors. (Courtesy of the Figawi Archives.)

PATTI AND JUDY SELLING SOUVENIRS, 1982. Patti Nurse (left) with Judy Sullivan are modeling some of the souvenirs outside the Figawi tent in 1982. For sale were hats, visors, T-shirts, sweaters, belts, jackets, and key chains. (Courtesy of the Figawi Archives.)

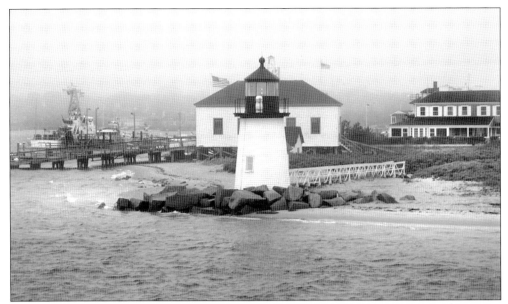

BRANT POINT LIGHT. Brant Point Light is a lighthouse located on Nantucket Island. The station was established in 1746, automated in 1965, and is still in operation. The current wood tower is 26 feet high and was constructed in 1901. It stands on shore at Brant Point and marks the entrance channel to Nantucket Harbor. It is always a point of destination for Figawi Race skippers as they make their way to the finish line, just offshore of the island. The current fog signal is the sound of a horn, which blows once every 10 seconds. (Courtesy of Britt Crosby.)

FIGAWI BRAIN TRUST, 1978. Some of the Figawi organizers are gathered in the old tent in Nantucket to make some last-minute critical decisions. From left to right are Dennis Sullivan, John Linehan, Joe Hoffman, Bob Horan, and Frank Saunders. It was John Linehan who, on his sail over to Nantucket, would paint the aluminum pie plates, which were the first trophies, presented "not necessarily to the winners," by the Figawi Committee. (Courtesy of the Figawi Archives.)

DENNIS SULLIVAN CHEERING IN THE FIGAWI TENT, 1980. Dennis Sullivan, longtime Figawi Committee and race committee chairman, is shown here encouraging someone or something going on in the tent in 1980. From left to right are John Flaherty, Ginny Flaherty, Sullivan, Judy Sullivan, Keran Lockhart, and Chuck Lockhart (behind Karen). (Courtesy of Figawi Archives.)

JOHN LINEHAN, 1974. Figawi lost one of its earliest supporters in 2004. John Linehan taught many participants, and some of the board as well, the simple joys of sailing. In the early days of Figawi awards, he would hand out aluminum pie plates bearing his original artwork, which captured the essence of some of the racers' best—and worst—moments. (Courtesy of the Figawi Archives.)

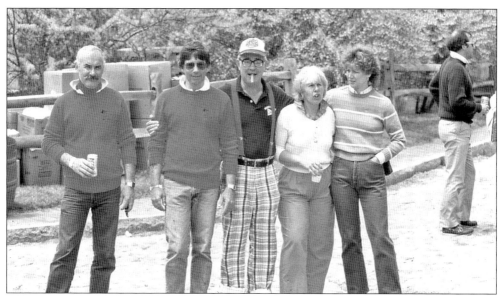

EARLY FIGAWI COMMITTEE MEMBERS, 1979. In the early and mid-1970s, there were not many big sailboats on Cape Cod. Most of the racing was done in Beetlecats, 19-foot Cape Cod Knockabouts, and 22-foot Wianno Seniors. A big-boat fleet started to race at the Hyannis Yacht Club (HYC) in 1977, and those skippers continued to feed into the Figawi Race. Pictured are some of the HYC members on the Figawi Committee; they are Fred Ellis, Fred "Skip" Scudder, Chuck Lockhart, Keran Lockhart, and Sandy Scudder. (Courtesy of the Figawi Archives.)

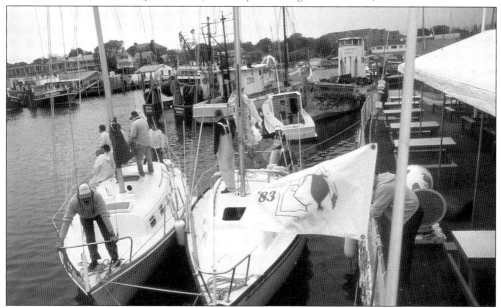

POST-RACE PARTY AT BAXTER'S, 1983. It quickly became a Figawi tradition that the racing boats and their friends would gather at Baxter's for a post-race celebration, and that tradition continues today. Easily the most famous on-the-water bar on Cape Cod, Baxter's often attracted 40 to 50 boats tied to one another and then to the Baxter's deck. On many occasions, a police boat had to escort the scheduled ferryboats through the traffic created by the rendezvous at Baxter's. (Courtesy of the *Cape Cod Times*.)

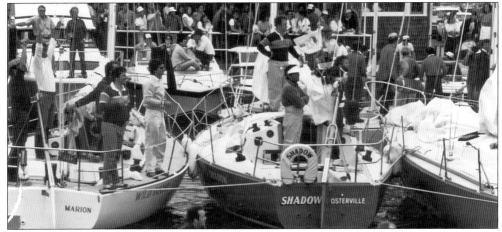

FIGAWI TAKEOVER AT BAXTER'S, 1983. *Wild Goose* out of Marion and *Shadow* hailing from Osterville are in the center of the action as the Figawi skippers and crews party it up at Baxter's Boathouse Club in Hyannis. One hundred fifty sailboats made the start of the Figawi Race to Nantucket in 1983, and it seemed like most of them ended up at Baxter's. The first-place winners in 1983 were Wiley Wakeman on *Wild Goose*, Peter Galvin skippering *Ragtime*, Joe Conway at the helm of *Steal Away*, Fletcher Street with *Tarot*, Frank Rooney onboard *Sorceress*, Russ Hamlyn driving *Sensuous Turkey*, Curtis Hill on *Kahlua*, Colin Robin and *Bow-Wow*, and Tom Leach sailing *Deliverance*. (Courtesy of Ed O'Neill.)

WHERE IT ALL BEGAN. Baxter's Boathouse Club on the Hyannis Inner Harbor was where Bob and Joe Horan, along with Bob "Red" Luby, made the wager on which of their boats would be the fastest in a race to Nantucket in 1972. It became known as the Figawi Race and has happened each Memorial Day since. When the sailboats come back from Nantucket on Monday, many of them still raft up at Baxter's to wind down the weekend. (Courtesy of R.S. Walters Advertising and Baxter's Boathouse Club.)

Two

Figawi Boats

It has been guesstimated that, over the years of Figawi racing, almost 5,000 different sailboats have participated. The event gained popularity primarily because it was designed for the weekend sailor who owned a rather small boat and loved to sail with family and friends.

Remember that early on, the first winner was *Red Rooster*—kind of a normal workingman's boat—and then there was the weirdest boat of all in the second race, *Moby Dick*.

As the years went on, there were more and more skippers who heard about this weekend stay on Nantucket, and the Figawi fleet started to get bigger and bigger. Buzzy Schofield certainly remembers "The Big Blow" of 1981, when he brought his two racing boats to Figawi. Schofield had a view from the stern of *Destination* when her sister ship *Arieto* shattered her spinnaker.

It was the maxi-machine named *Matador* that carried Osterville's Bill Koch to victory in both of his Figawi appearances in 1986 and 1987. Another standout was the J-Class sailboat *Shamrock V*; she did the race in the mid-1990s. The committee had come a long way, and to top it off, the *Weatherly, Intrepid, Columbia,* and *American Eagle*—the America's Cup 12-meters—also started sailing in the Figawi.

There were also some memorable boat names that come to mind when looking back at the history of this race, like *Deliverance, Bow-Wow,* and *Fog Dog*. Top honors, it seems, should go to the following: *Hot Ruddered Bum, Brace Yourself Bridget,* and *Shoot Low They're Riding Chickens*.

The Figawi has seen it all over the years, but there are always more boats to come.

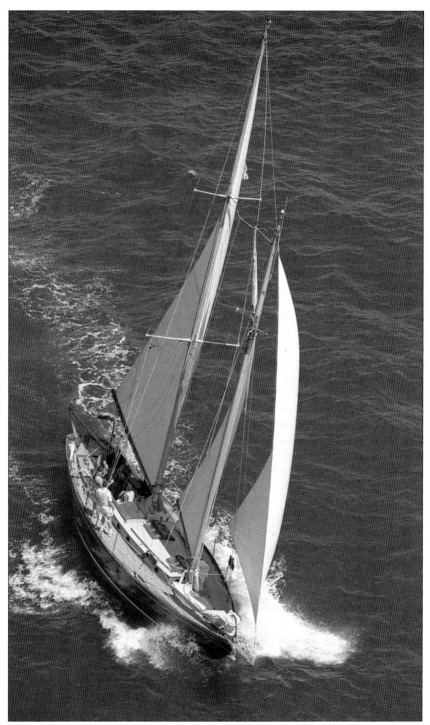

Mya from Up Top, 2000. Pictured here is a beautiful overview of the Concordia 50-foot schooner *Mya*, as she is sailed on Nantucket Sound in the Figawi Race in 2000. *Mya*'s owner and skipper, Sen. Ted Kennedy, won a first-place trophy in Figawi 1989. (Courtesy of Steve Heaslip and the *Cape Cod Times*.)

THE GEMINI TWO, 1981. Dennis Sullivan, the hired hand at the helm, and owner Frank Marshall beneath him, maneuver Gemini Two on its way to Nantucket in 1981. Leo Gildea, always suspect as the race navigator, is to the left of Sullivan. Gemini Two, a Hunter 30, went home that weekend with a first-place trophy in the Streaker division. (Courtesy of the Figawi Archives.)

MR. OWL TO YOU, 2007. Sailors aboard the Owl trim their sails as they head out from Hyannisport after crossing the starting line and heading to Nantucket. The Owl is a Rhodes Reliant 41, sailed by Richard Currier from Cambridge, Massachusetts. Currier recently had the boat reconstructed in Kennebunk, Maine, and his best Figawi finish was a third place in Class E in 2009. (Courtesy of Steve Heaslip.)

GRINDING AWAY ON AMERICAN EAGLE, 1995. The 12-meter American Eagle is grinding away on deck in the 1995 Figawi Race to Nantucket. The grinders, of course, are big winches used to raise and trim the sails as the skipper determines what adjustments may be necessary to make the boat go faster. American Eagle was one of many 12-meter machines to have sailed the Figawi Race over the years. (Photograph by and courtesy of John Leaning.)

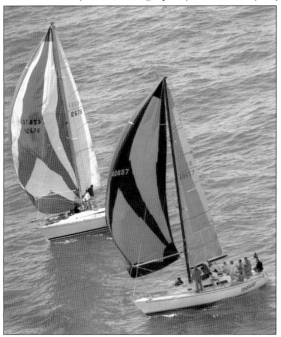

BIG SPINNAKERS LEADING THE WAY, 1996. In front and in control of the wind, the Insatiable, owned by Bill and Kate Jones of Marblehead, smothers Adulis and Jack Ellison, as the boats battle for the lead in the 1996 Figawi Race. As it turned out, neither finished in the money; however, both came back to fight it out again. (Courtesy of Steve Heaslip.)

LOOKING DOWN ON THE *EAGLE*, 1997. The *American Eagle* is seen from overhead as she cuts through the waters off Hyannis Port in light winds, headed for Nantucket in the 26th sailing of the Figawi Race. America's Cup 12-meter class vessels made a great contribution to the status of the Figawi over the years, as these sleek and powerful racing machines competed for a dozen years. (Courtesy of Steve Heaslip.)

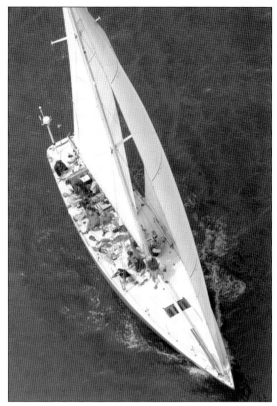

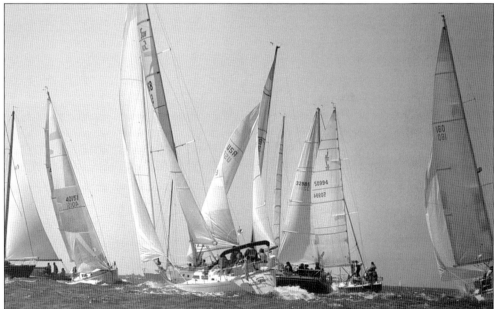

THE FLEET WAITING TO CUT LOOSE, 1998. Waiting for the race to begin, Figawi sailors jockey for position in the waters off Hyannisport. For most of these big racing vessels, it is about 26 miles from Hyannisport to the finish line just outside of Nantucket. At this stage, the skippers are just waiting to turn them loose. (Courtesy of Steve Heaslip.)

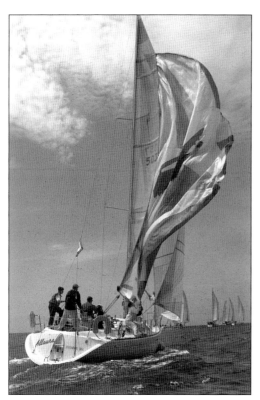

THE ALLAURA, 2001. The crew of the *Allaura* heads toward the first mark in the 30th Figawi Race to Nantucket. *Allaura* is a Beneteau 35, skippered by Bill Abbott out of the Hyannis Yacht Club. It seems as if they are having trouble flying the old Izod alligator spinnaker that they must have bought from Charlie McLaughlin. *Allaura* has two Figawi wins, in 2004 and 2007. (Courtesy of Steve Heaslip.)

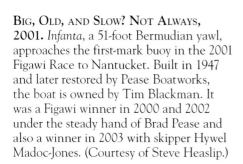

BIG, OLD, AND SLOW? NOT ALWAYS, 2001. *Infanta*, a 51-foot Bermudian yawl, approaches the first-mark buoy in the 2001 Figawi Race to Nantucket. Built in 1947 and later restored by Pease Boatworks, the boat is owned by Tim Blackman. It was a Figawi winner in 2000 and 2002 under the steady hand of Brad Pease and also a winner in 2003 with skipper Hywel Madoc-Jones. (Courtesy of Steve Heaslip.)

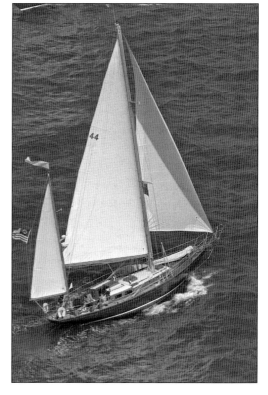

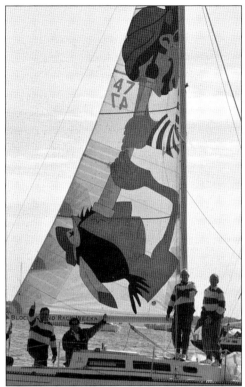

"And the Winner Is . . ." in 2010. Crew members of the *Club Car* wave to friends dockside as they fly their Figawi sail heading out of Hyannis for the starting line in 2010. The image on the sail reflects the ongoing battle within Figawi regarding the old Indian-head logo versus the newer pirate logo, as they stare each other down through the spyglass. Barry Bessette from Chatham is the owner/skipper of *Club Car*, which was a Figawi winner in 2008. (Courtesy of Steve Heaslip.)

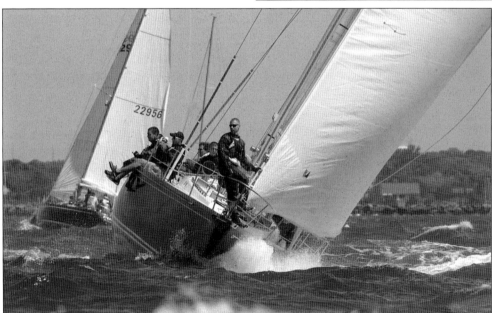

Charging Ahead, 2010. Figawi sailors cut through rough surf in waters off Hyannisport, as they make their way to a timed start for the 39th passage across Nantucket Sound. Some 225 sailboats have entered this year's race and with a good wind, the bigger and faster boats will make the trip in a little over two hours. They are all hopeful of winning a share of the handsome Figawi Race trophy. (Courtesy of Steve Heaslip.)

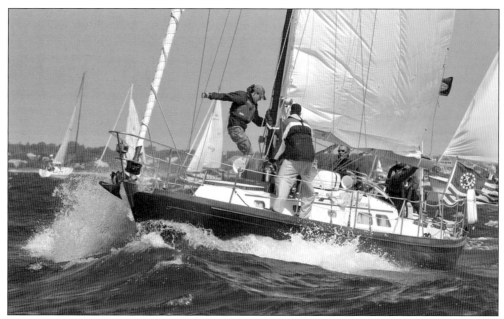

The Magic Dragon, 2010. The crew on the *Magic Dragon* fights a heavy surf as they head for the Figawi starting line on Nantucket Sound. Steve DeMenna is the owner and skipper of the 42-foot Hinckley Sou'Wester out of Hingham, Massachusetts. By the end of the day, everybody will know if this *Dragon* is really *Magic*. (Courtesy of Steve Heaslip.)

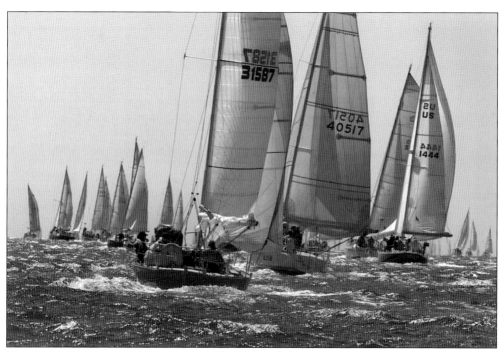

The Figawi Fleet at the Start, 2002. The Figawi fleet, some 200 boats strong, powers past the starting line at Hyannisport and heads to Nantucket. (Courtesy of Steve Heaslip.)

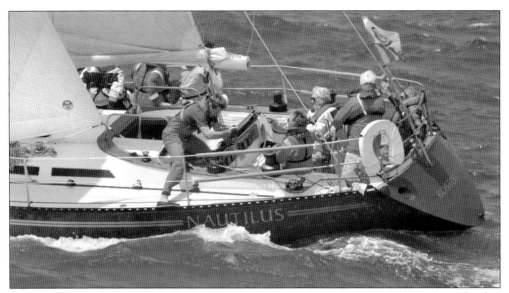

A NEW YORK 40 OUT OF BOSTON, 2012. The crew on the *Nautilus* cranks in the sails after their start in the 41st annual Figawi Race from Hyannis to Nantucket. Terrence Sullivan is the owner/skipper of this New York 40, which sails out of Boston, and Sullivan is a member of the New York Yacht Club. *Nautilus* has finished near the top in some past races but has yet to get a Figawi win. (Courtesy of Steve Heaslip.)

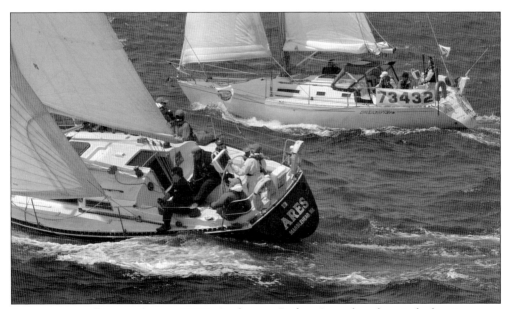

ADVANTAGE TO BROKEN ARROW, 2012. At the top, *Broken Arrow* has the wind advantage over *Ares* shortly after the start of the Figawi Race to Nantucket. *Ares* is a C&C 40 sailing out of Marblehead and skippered by Linda Hosking. As for *Broken Arrow*, a Beneteau First 37.5, her skipper is Peter MacPherson from Wayland, Massachusetts. (Courtesy of Steve Heaslip.)

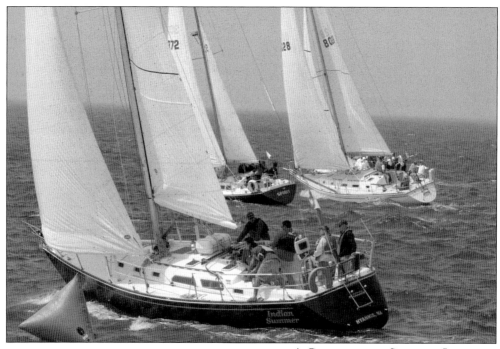

A CROWD AT THE STARTING LINE, 2012. From the top, *Shindig*, with a slight advantage at the start, is a Pearson 39, sailed by Kevin Flannery out of Newport, Rhode Island. Flannery, who lives in Waban, Massachusetts, has sailed *Shindig* in the Chicago-to-Mackinaw Race, the Buzzards Bay Regatta, and the Newport-to-Bermuda Race, and was a winner in the 2008 Figawi Race. In the middle is the C&C 34 *Spirit*, skippered by Barry Lawton. And at the bottom is *Indian Summer*, a Sabre 38-2, sailed by Bing Carey from Hyannis. Carey is a member of the Hyannis Yacht Club and a Figawi winner in 2007. (Courtesy of Steve Heaslip.)

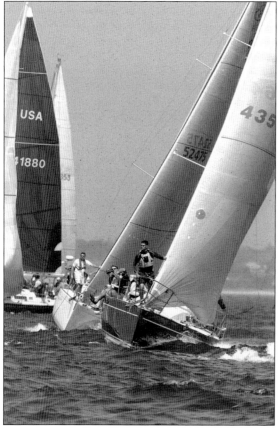

GREMLIN, 2007. The bowman keeps an eye on traffic as the *Gremlin* waits to cross the starting line and head to Nantucket. *Gremlin* is a Tripp 36, skippered by Bruce Cathcart from Mystic River, Connecticut. Another boat is close to catching up with the *Gremlin* in this picture. (Courtesy of Steve Heaslip.)

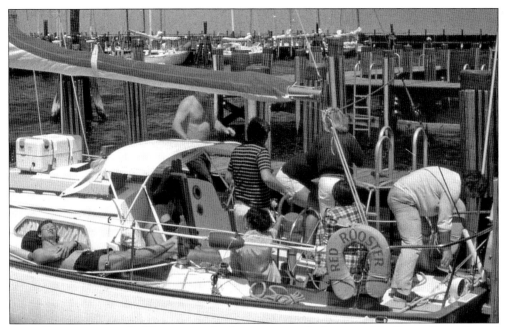

No. 1 Rooster, 1991. *Red Rooster* was the first winner in the history of the Figawi Race. Owned and operated by Bob "Red" Luby, who beat out the Horan brothers in 1972, the *Rooster* will always have a time-honored position in the history of this event. Red maintained a strong relationship with Figawi over the years. He loved sailing and, in 1977, he did the Marion-to-Bermuda Race in *Red Rooster* and sailed in the 25th annual Figawi in 1996. The Figawi Board of Governors honored Red in 1991 with the Pamela Trussell Duggan Special Recognition trophy. Bob "Red" Luby passed away in 1996. (Courtesy of the Figawi Archives.)

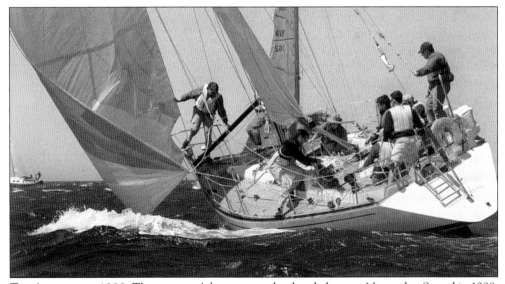

The Advantage, 1998. The crew on *Advantage* gets her headed out on Nantucket Sound in 1998. The *Advantage* sails out of New Castle, New Hampshire. (Courtesy of the *Cape Cod Times*.)

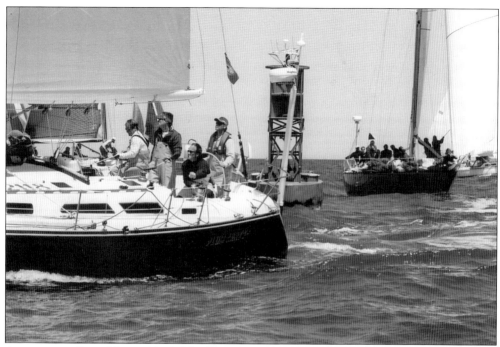

AROUND THE LAST MARK, 2004. The fleet is powering around buoy No. 1 and setting a course for the finish line just off Brant Point, Nantucket. In the foreground, it is *Plum Crazy* cranking in the genoa and doing whatever it can to get there first. (Courtesy of Blake Jackson.)

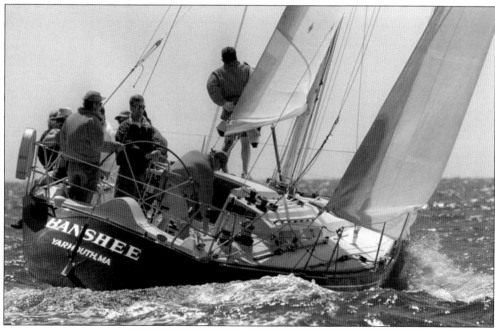

BANSHEE SETTING TO WINDWARD, 1995. The crew onboard *Banshee* sets the sails for a long leg windward, as she plows through the sea on the way to Nantucket. Joe O'Neal from Yarmouth, Massachusetts, sails his boat out of the Hyannis Yacht Club. (Courtesy of Steve Heaslip.)

BLACK TIE AND TAIL . . . WIND, 2008. The skipper and crew on *Black Tie* are all set for a long leg with the wind at their back. There's nothing for the crew to do now except enjoy the ride. (Courtesy of Paul Blackmore.)

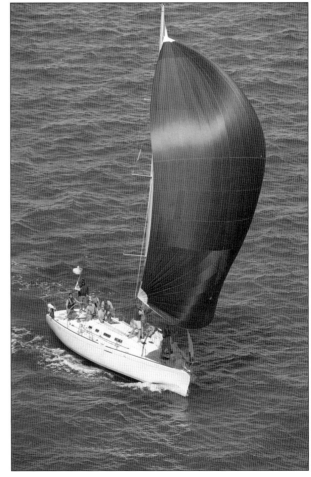

AN INCOGNITO RACER, 2000. It is difficult to identify this Figawi sailboat. With the huge black spinnaker flying and no sail numbers to read, she will steal her way to Nantucket. (Courtesy of the *Cape Cod Times*.)

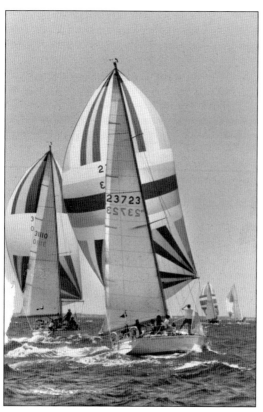

BLOWIN' IN THE WIND, 1983. John Osmond's C&C 40 *Thorfinn* No. 23723 sets off on a spinnaker reach in Figawi 1983. Osmond, a Figawi committee member since 1974, won the race in 1975, 1978, and 1980. John would win again in 1990 as part of the crew on *Brigadoon VI*. This picture would be the cover photograph for the first Figawi program book in 1984. (Courtesy of Roger Newson.)

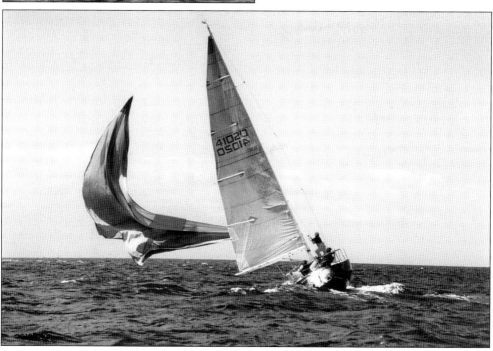

NOT ALWAYS A GOOD DAY ON THE WATER. An unidentified Figawi racer tries to tame an out-of-control spinnaker on his way to Nantucket. (Courtesy of the Figawi Archives.)

ROUNDING THE MARK. The jib is up with the spinnaker down as this sailor rounds racing mark buoy No. 1 and takes a heading for Nantucket. (Courtesy of the Figawi Archives.)

HALF OF THE BOAT'S BOTTOM, 2010. This hard-to-identify boat is out of East Greenwich, Rhode Island, and she seems to be leaning her way to Nantucket. However, she has found a spot on Nantucket Sound where she has plenty of good air and nobody else around. (Courtesy of Blake Jackson.)

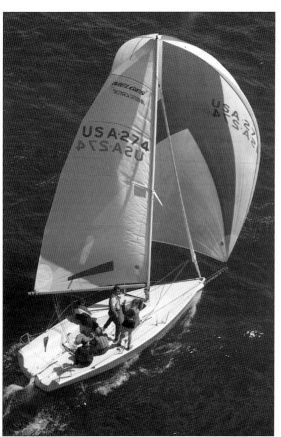

Taking a Break, 2000. The crew on this USA-274 Melges-designed boat takes a break as they head downwind in the 2000 Figawi Race. (Courtesy of Steve Heaslip.)

The Senator at the Helm, 2008. Ted Kennedy had pledged to sail the 2008 Figawi even as doctors determined he had a malignant brain tumor. He missed the race to Nantucket on Saturday and had already asked then-candidate Barack Obama to fill in for him and deliver a commencement address on Sunday. The senator got up early on Monday, took a ferry from Hyannis to the island, and sailed his 50-foot schooner *Mya* in the return race back to Hyannis. With him aboard the *Mya* were his wife, Vicki, sons Edward Jr. and Patrick, stepdaughter Caroline Radin, and former Connecticut senator Christopher Dodd. (Courtesy of Ed O'Neill.)

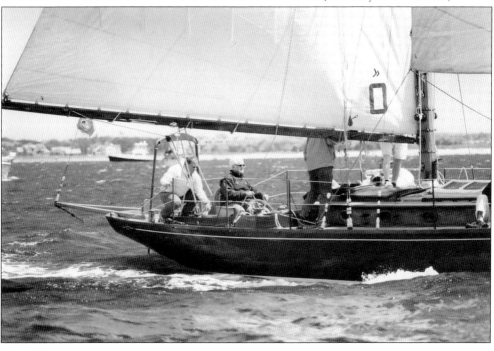

An Izod Alligator Back in the 1980s. Not that the gator made Charlie McLaughlin's *Independence* go any faster, but it sure was a hot item on the water. McLaughlin has been a board member for almost as long as Figawi has been around. (Courtesy of the Figawi Archives.)

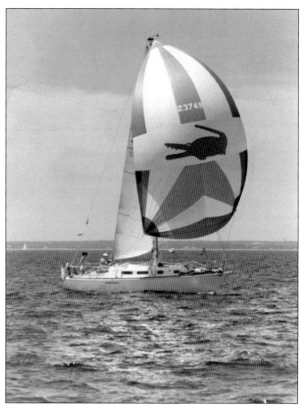

Lawson's *Skysweeper*, Mid-1970s. Bill Lawson is on the tiller of *Skysweeper*, his Cal 30, in one of the earlier Figawi Races over to Nantucket Island. (Courtesy of the Figawi Archives.)

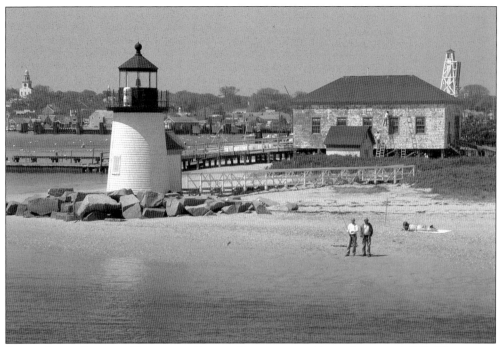
BRANT POINT STATION GETTING A COAT OF PAINT AS THE FLEET ARRIVES, 2005. The station building at Brant Point Light gets a fresh coat of white paint as the Figawi fleet arrives in 2005. Nantucket Harbor is just beyond the light station. (Courtesy of Ed O'Neill.)

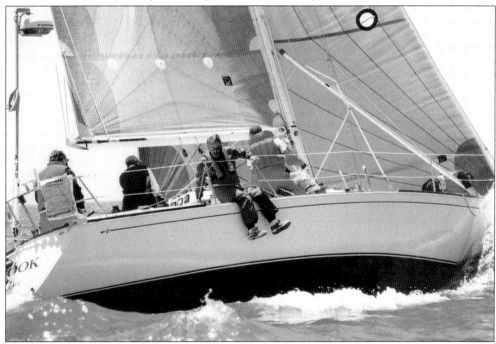
CHINOOK BEARING DOWN ON THE ISLAND, 2003. *Chinook*, hard on the wind and under the control of Neil Tomkinson and his crew, tacks its way to Nantucket. Tomkinson is a Figawi winner from 1986, 1992, 1997, and 1999. (Courtesy of Blake Jackson.)

COCONUT BATTLING A SPINNAKER CHANGE, 2006. She is trying to get a second chute up with the first one in the water. Nobody said this would be easy. Skipper Tom D'Albora and *Coconut* took home the first-place trophy in the E Division in 2006. (Courtesy of Ed O'Neill.)

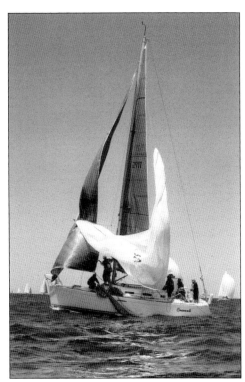

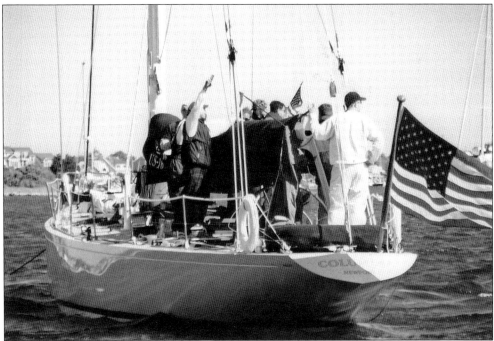

COLUMBIA US-16, ONE OF THE 12S, 1999. *Columbia*, designed by Olin Stephens, was the successful defender of the 1958 America's Cup for the New York Yacht Club. She defended against the challenger *Sceptre* and is seen here outside of Nantucket Harbor after competing in Figawi 1999. (Courtesy of Ed O'Neill.)

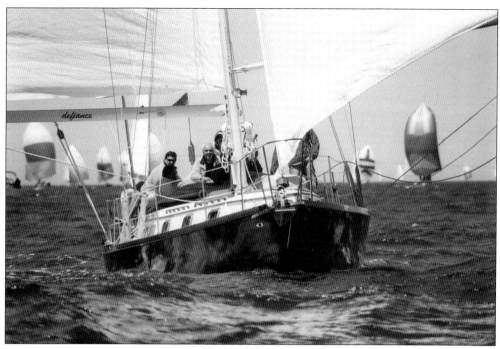

DEFIANCE, 2005. The fleet is downwind with spinnakers flying as *Defiance* is trying to stay out in front. Bob Cicchetti's boat is an 11-time winner of the Figawi trophy. (Courtesy of Blake Jackson.)

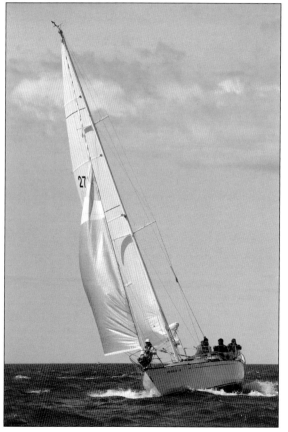

BEATING ONE'S WAY TO NANTUCKET, 2008. With the crew on the rail and Nantucket in sight, *Desiree* powers for the finish line in 2008. This boat, owned by Bob Rozene and his wife, Ginny, sails out of the Hyannis Yacht Club. (Courtesy of Blake Jackson.)

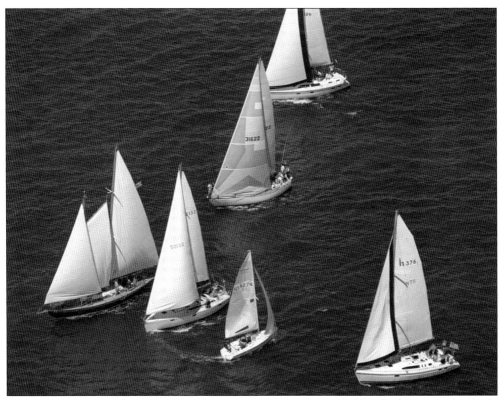

A TRAPPED MELGES GOING THE WRONG WAY, 2000. Surrounded by the big guys, this little Melges, USA-274, tries to get out of their way. With no other choice, he makes a tactical decision in the 2000 Figawi Race. (Courtesy of Steve Heaslip and the *Cape Cod Times*.)

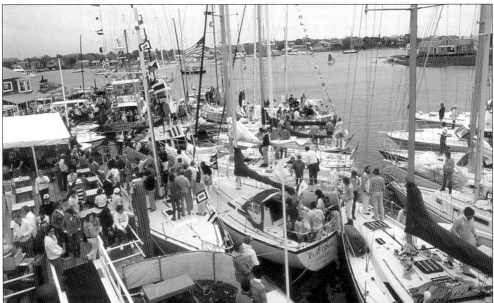

AT BAXTER'S, 1983. Here is an elevated view of the rafting party at Baxter's in 1983. It is a Figawi tradition and a great way to wind down the weekend. (Courtesy of the *Cape Cod Times*.)

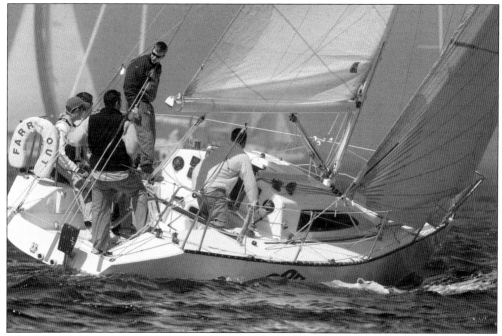

No Stepping Back, 2005. Skipper Russel Henchman and crew work the *Farr Out* into position off Hyannisport for the start of the 34th Figawi Regatta. The boat is a Farr 30 that sails out of Milford, Connecticut. (Courtesy of Steve Heaslip and the *Cape Cod Times*.)

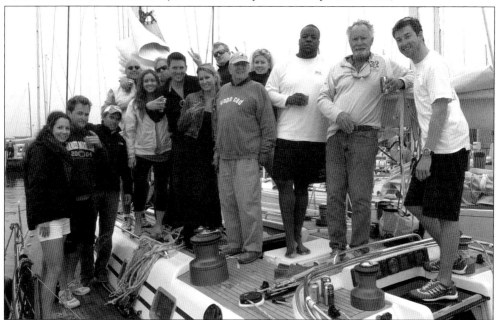

Desmond and Crew Enjoy a Win, 2007. Jack Desmond and his crew pose for a post-race picture in the 2007 Figawi race. Jack started sailing back in 1978 out of Bass River, Massachusetts. The Figawi is always the first event on the *Affinity* summer schedule, and Desmond was a winner in 1995, 1998, 2000, 2001, and 2007. *Affinity*, a Swan 48, races the Caribbean circuit during the winter months before heading north to sail Figawi in May. (Courtesy of Britt Crosby.)

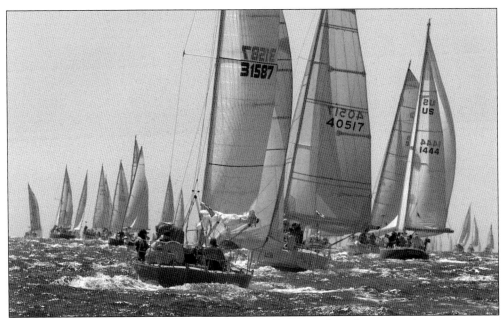

WAITING FOR THE GUN, 2002. Much of the Figawi fleet is circling the starting line as the racers wait for the sound of the gun from the committee boat. Once these big boats get going, it will only take about three hours to get to Nantucket. This race has always used a delayed start, so that the slower boats go first, and the fast guys start later. (Courtesy of Blake Jackson.)

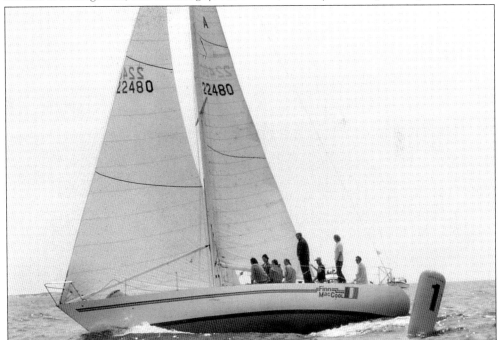

ALAN SMALL'S *FINN MACCOOL*, C. 1981. Alan Small raced two different boats in the Figawi Race in the early years. He won back-to-back in 1976 and 1977 with a boat named *Tuesday's Child*. Here, Alan is seen steering *Finn MacCool* in about 1981. Unfortunately, with the *Finn*, he never got another victory. (Courtesy of the Figawi Archives.)

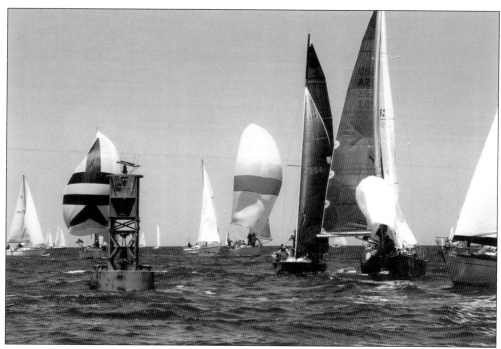

GET THE CHUTE DOWN. As the fleet approaches this rounding mark, the crews need to douse the spinnakers and get set up for a beat to windward. (Courtesy of Blake Jackson.)

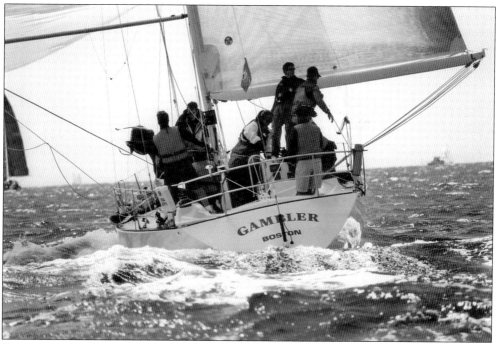

GAMBLER ON THE DOWNWIND LEG, 2005. John Downey at the wheel of *Gambler* heads downwind in the Figawi Race in 2005. Downey is a Hyannis Yacht Club member and races the Figawi mostly with members of his family. (Courtesy of Blake Jackson.)

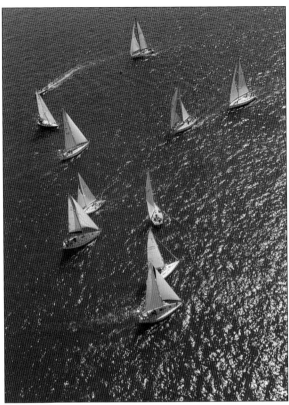

HIGH ABOVE THE FIGAWI FLEET SAILING TO NANTUCKET, 2000. Pictured here is a bird's-eye view of some of the fleet, as they prepare to make their way to Nantucket. (Courtesy of Steve Heaslip and the *Cape Cod Times*.)

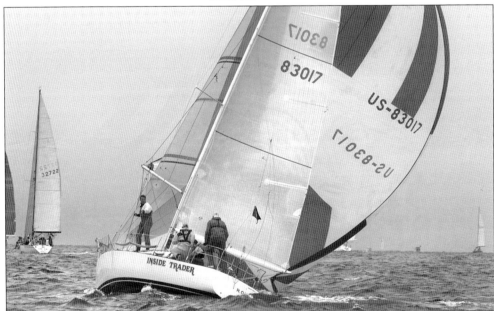

REACHING WITH THE INSIDE TRADER, 2003. The J-35 *Inside Trader* airs out its spinnaker to the waterline, as it power-reaches toward Nantucket. Trevor Underwood is the owner/skipper of the *Trader*, and he lives in Annapolis, Maryland. (Courtesy of Steve Heaslip and the *Cape Cod Times*.)

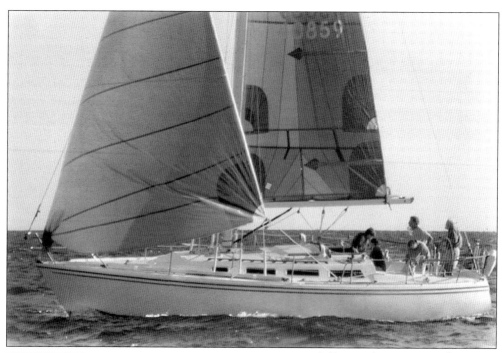

A Family Affair, 2003. Joe O'Loughlin is pictured here at the wheel of his sailboat *Tabu*, as they smoothly cruise their way over to Nantucket. *Tabu* is a Catalina 36-footer, and the O' Loughlins almost always have the family onboard, both young and not-so-young. This is a team that has almost perfect attendance for this race. (Courtesy of Blake Jackson.)

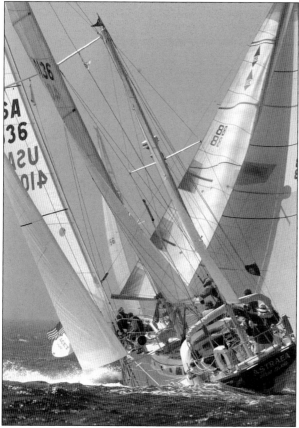

Skippers Mustering at the Start, 2005. The skippers are pressing for position at the start of the 34th Figawi Race to Nantucket. More than 200 boats in 16 classes make up the fleet, in what is recognized as one of the premier regattas in New England. (Courtesy of Steve Heaslip and the *Cape Cod Times*.)

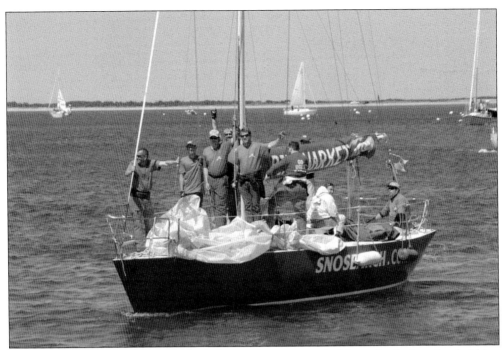

OWNER MUST BE A GEEK, MID-1990S. As *Snosearch.com* enters the Nantucket harbor after finishing the Figawi Race, her skipper and crew are looking for a place to tie up and unwind. Skipper Paul Tetreault is in the ski business, not the dot-com business. (Courtesy of Ed O'Neill.)

MAX(ED) OUT, 1996. The crew of the *MaxOut* makes fast their sails as they head for the finish line just off Brant Point on Nantucket. (Courtesy of Steve Heaslip and the *Cape Cod Times*.)

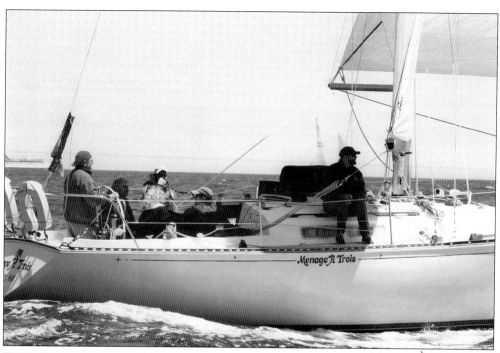

MENAGE À TROIS. This C&C 37 and her skipper Peter Ogren from Nantucket are about to get started in a race that will take them home to the Grey Lady. (Courtesy of Blake Jackson.)

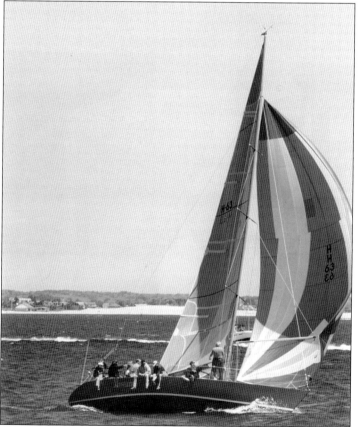

MUSTANG BLOWS BY THE NANTUCKET SHORELINE. With her spinnaker powering her on a reach, the vessel *Mustang* moves along the Nantucket shoreline. (Courtesy of Blake Jackson.)

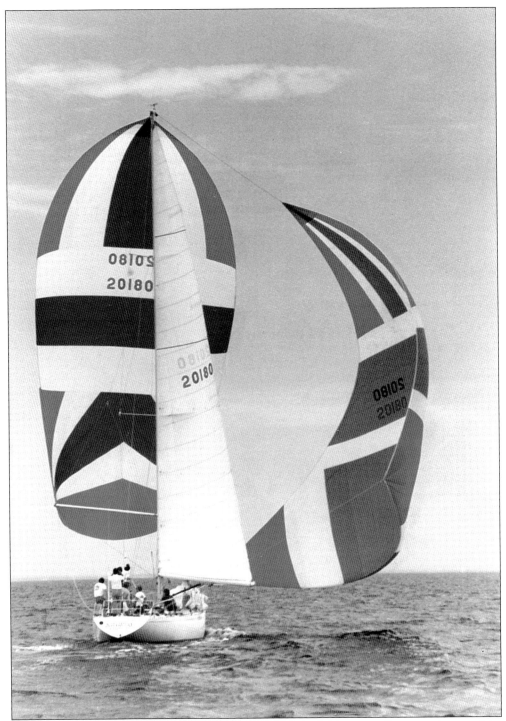

ARIETO WITH SPINNAKER FULL, 1982. In 1981, Buzzy Schofield came to Figawi with one of the first real go-fast racing boats in this event. He was the Class A winner that year with *Destination*. Here is another Schofield-skippered machine, *Arieto*, a Frers 46, which won the same division in 1982. (Courtesy of the Figawi Archives.)

"Set the Spinnaker and Let Her Go," 2004. *Nepenthe* looks for some clean air as skipper Robert Read of Barrington, Rhode Island, tries to make some time on the fleet. *Nepenthe* is a Pearson 39 and won a Class C trophy in 1994 and the Class D trophy in 1998. (Courtesy of Blake Jackson.)

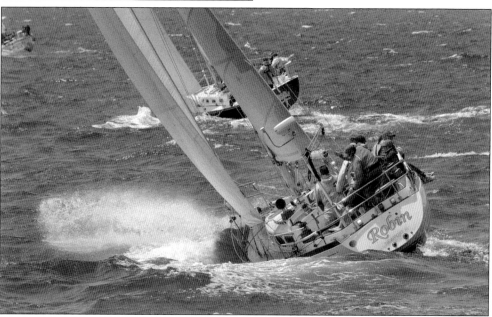

Robin Diving into an Ocean Hole, 2008. *Robin*, out of Newport, Rhode Island, and owned by David Pignolet, is trying to get something going here in some very rough water. The boat is a Little Harbor 38 with a Performance Handicap Racing Fleet (PHRF) rating of 132. (Courtesy of Steve Heaslip and the *Cape Cod Times*.)

CHEROKEE IN THE HUNT, 1988. Ron Sears, with the tiller in his hand, seems to have his J-24 *Cherokee* on a spinnaker reach. Sears was a first-place winner in Class K in 1988. (Courtesy of the Figawi Archives.)

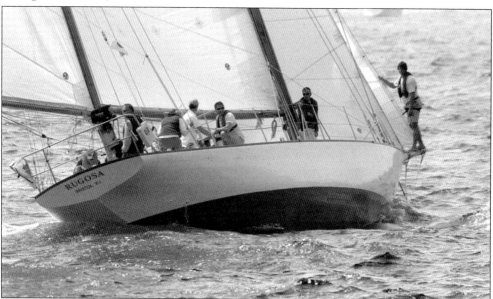

RUGOSA, FOUND AND RESTORED, 2007. *Rugosa*, a New York 40 that was designed and built in 1915, was found by Halsey Herreshoff in the mid-1980s. Herreshoff restored the boat between 1986 and 1991 and then sailed the Figawi with it in 2007. Michael Deeley of Osterville donated the Herreshoff Marine Museum trophy to Figawi to honor the outstanding efforts of Halsey Herreshoff and the museum in preserving the history of New England's premier yacht builders and yachtsmen. (Courtesy of Steve Heaslip and the *Cape Cod Times*.)

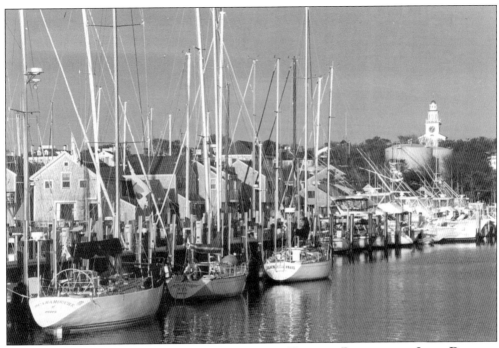

THREE AT REST AFTER A LONG DAY, 2005. *Scaramouch*, *Artful Dodger*, and the *Black Pearl* lay alongside the Nantucket dock after a long, hard day on the water. (Courtesy of Ed O'Neill.)

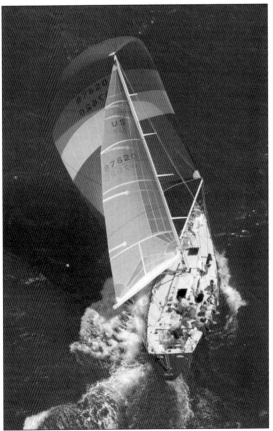

A SECRET, 1999. The *Secret*, a Nelson Marek 42 skippered by Bruce Kuryla of Milford, Connecticut, flies its spinnaker as it nears the end of the Figawi Race to Nantucket. (Courtesy of the *Cape Cod Times*.)

A STAMPEDE, 1983. *Stampede* raced in the Figawi in 1983 and was skippered by Weston Adams Jr., who owned the Boston Bruins. *Stampede* was a Baltic 46-footer. (Courtesy of the Figawi Archives.)

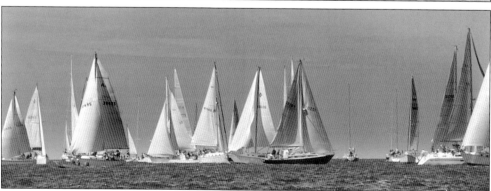

THE START IN 2000. Boats are anxious to go, as the Figawi fleet musters near the starting line in 2000. The boats are all rated and start at different times, but the race committee's objective is that they will all arrive in Nantucket at the same time. (Courtesy of Ed O'Neill.)

WEATHERLY US-17 AT FIGAWI, 2002. Weatherly was launched in 1958 but was eliminated in the selection trials held that year in favor of *Columbia*. After a redesign, Weatherly was selected to defend the America's Cup in 1962 and won her match 4-1 against *Gretel*. Weatherly was the first-place trophy winner in the Figawi Race in 1999 and 2002 with skipper Bob Matthews. She won Figawi again in 2006 with Mox Tan on the wheel. (Courtesy of the *Cape Cod Times*.)

SAIL NO. 216 ARRANT ROSE, 2008. Getting off to a good start is a Trident Voyager by the name of *Arrant Rose* and her owner/skipper Richard Glaser. (Courtesy of Blake Jackson.)

Dr. Prizzi has a Vendetta. The jib is down and the spinnaker is flying on *Vendetta* as she makes slow progress on her way over to Nantucket. Vendetta is a Peterson 34-footer that is owned and skippered by Tony Prizzi out of the Hyannis Yacht Club. This race is slow, but his spinnaker is full! (Courtesy of the Figawi Archives.)

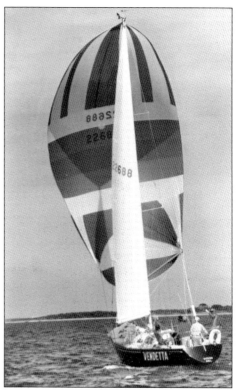

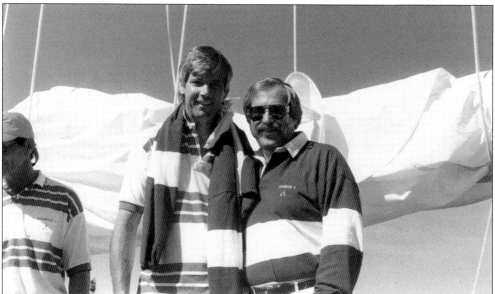

Shamrock V, One of the Magnificent Js. On the left, Gary Jobson and John Osmond can be seen aboard Sir Thomas Lipton's J-Class yacht *Shamrock V* during the first matchup with *Endeavor* in Newport, Rhode Island. Gary was the skipper of *Shamrock V*, and Ted Turner was the skipper on *Endeavor*. John was one of the 38 crew members, in charge of manning the lower runners. The lad in the hat to the left is Peter Isler. *Shamrock V* participated in two Figawi Races under the command of Whitey Russell in 1987 and again in 1988. (Courtesy of Ellyn Osmond.)

WARRIOR WITH A PROBLEM, 2003. Seems like a loose spinnaker sheet will slow the progress of *Warrior* and her skipper Tom Burrows of South Orleans, Massachusetts. (Courtesy of Ed O'Neill.)

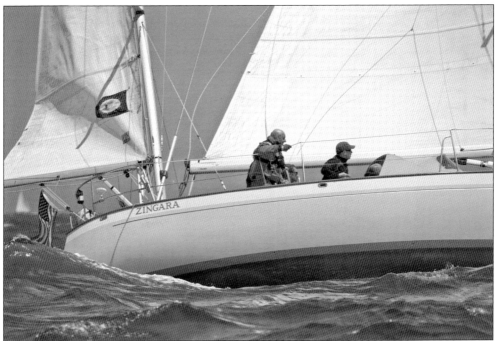

NANTUCKET, THE HOME OF ZINGARA, 2010. Chris Magee heads his 45-foot Peterson yawl *Zingara* straight for Nantucket in this Figawi Race. *Zingara* calls Nantucket home. Magee was a first-place winner in Figawi 2009. (Courtesy of Blake Jackson.)

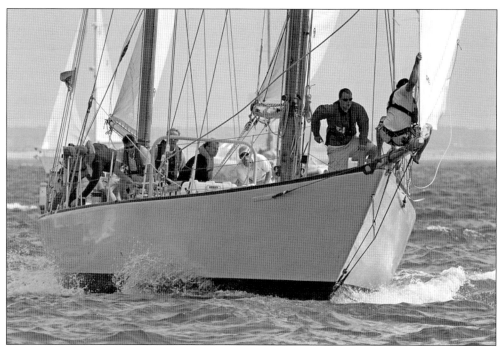

CHARGING TO THE FINISH, 2007. This Figawi boat is big, fast, and charging to the finish. This picture, in 2007, seems to explain just why people love to sail. (Courtesy of Blake Jackson.)

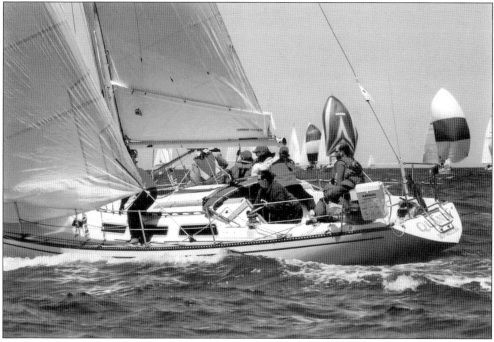

QUANDY OUT IN FRONT. The Figawi Race boat *Quandy* has rounded the mark and trimmed her sails hard to the wind, graining ground on the spinnakers behind. *Quandy*, a Norwell, Massachusetts, boat, has hopes of getting a win as the crew searches for the Nantucket finish line. (Courtesy of Steve Heaslip and the *Cape Cod Times*.)

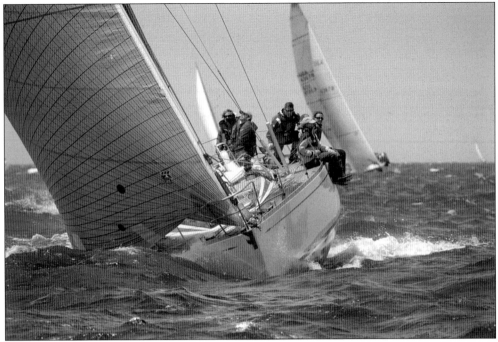

"COMIN' AT YA!" Photographer Blake Jackson needs to get out of the way. This 2009 Figawi competitor seems to know where he is headed, and nothing will get in his way. (Courtesy of Blake Jackson.)

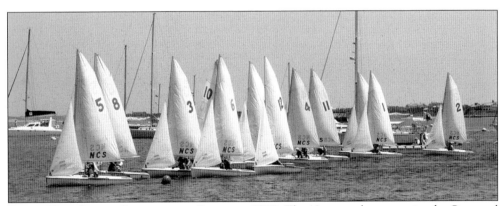

FIGAWI HIGH SCHOOL INVITATIONAL REGATTA, 2010. The 12 teams that comprise the Cape and Islands High School Sailing League battle it out on Sunday morning of the Figawi Race Weekend on Nantucket. The invitational was the brainchild of Howard Penn, George Bassett, and Nick Judson and began at the Figawi Race Weekend in 2000. (Courtesy of Britt Crosby.)

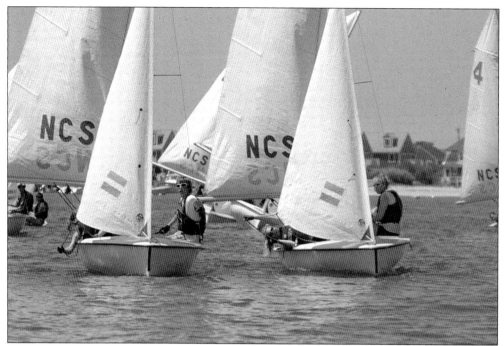

FIGAWI HIGH SCHOOL INVITATIONAL REGATTA, 2010. Sailors are pictured in the 2010 Figawi High School Invitational Regatta. The following were winners of the regatta: Belmont Hill, 2000; Harwich, 2001; Martha's Vineyard, 2002; Dartmouth, 2003; Dartmouth, 2004; Chatham, 2005; Barnstable, 2006; Barnstable, 2007; Nauset Regional, 2008; Bishop Stang, 2009; Dartmouth, 2010; Nauset Regional, 2011; and Barnstable, 2012. (Courtesy of Britt Crosby.)

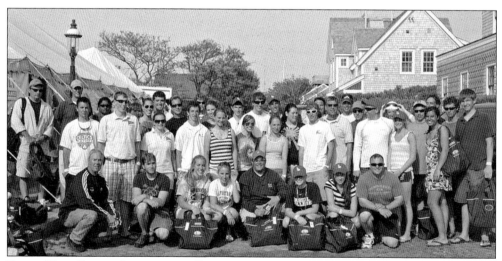

FIGAWI HIGH SCHOOL INVITATIONAL REGATTA, 2010. Here are the competitors from all the high schools in 2010. (Courtesy of Britt Crosby.)

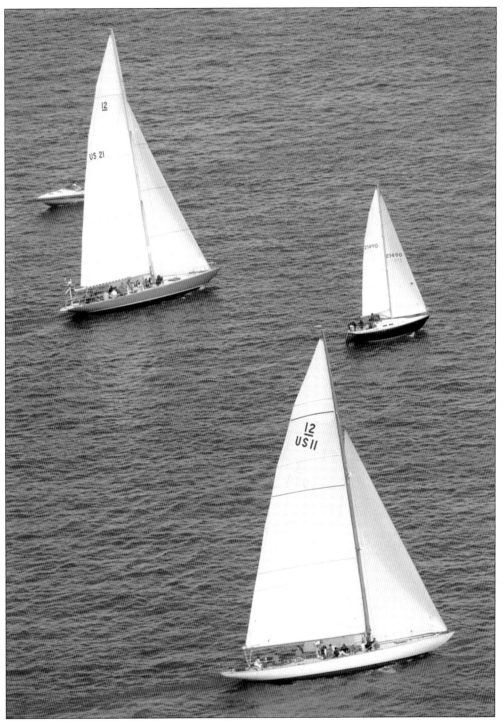

Two 12s, 1997. A pair of 12-meter boats, the *American Eagle* at top and *Gleam* at the bottom, jockey past a little guy in the waters off Hyannisport in 1997. These America's Cup legends are biding their time as they wait for the start of the annual Figawi Race to Nantucket. (Courtesy of Steve Heaslip.)

Three
SUNDAY ON NANTUCKET

On Sunday of the Figawi Race Weekend, things get started early on Nantucket. If someone still has to get some Figawi shirts, jackets, or maybe some hats, the store at the clothing tent is open. Also for those who plan to take in the Joke-Telling Session, the Band of Angels will get started at 10:00 a.m. and go until the last joke is told.

Then people can watch the Figawi High School Invitational, as the Cape and Islands High School Sailing League teams compete for trophies right in Nantucket Harbor. The crews sail in Club 420s loaned to Figawi by Nantucket Community Sailing and the Great Harbor Yacht Club. Each team enters one crew of two sailors, who are allowed to switch back and forth as skippers. The best place to get a look at this competition is from the end of the docks.

The Clambake gets underway at 1:30 p.m., and is a chance to enjoy an authentic New England tradition that includes lobster, steamers, clam chowder, sausage, chicken, corn on the cob, and a whole lot more.

The awards ceremony is next in the Figawi tent, when all of the racing results are announced and the skippers find just how well or not-so-well their boats finished. And the final event on the Sunday schedule is the tent party, which always features entertainment and dancing.

But a word to the wise should be sufficient: the return race to Hyannis will get underway at 9:30 a.m. the next day.

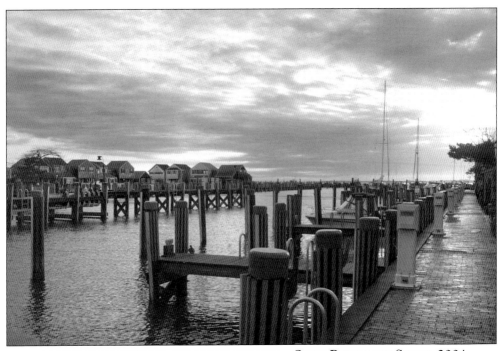

QUIET BEFORE THE STORM, 2004. Seen here are the docks at Nantucket early on Saturday morning, as they await the fleet of 225 boats and maybe 3,000 sailors and friends. (Courtesy of Ed O'Neill.)

SHELLEY MCCABE, 2011. Shelley's checking to see that the awards presentation is going along as planned. In 2012, the Figawi Board of Governors appointed Shelley to the post of executive director of Figawi Inc. (Courtesy of Britt Crosby.)

NOT A REAL CLAMBAKE WITHOUT CHICKEN, 1983. On the right, the lobsters are steaming, and to the left the chicken is on the grill. Bob Horan first heard about Carl Flipp when he was told that Leighton's Catering had done a New England Clambake for a few thousand people at the John F. Kennedy Library in Boston. If he can do that, Bob thought, he needs to come over to Nantucket. (Courtesy of the Figawi Archives.)

THE BAKE IS ON. Getting everything ready to go, the team from Leighton's Catering is monitoring the progress of the bake. The year 1979 was when the event was extended to three days, which included the introduction of the clambake. (Courtesy of the Figawi Archives.)

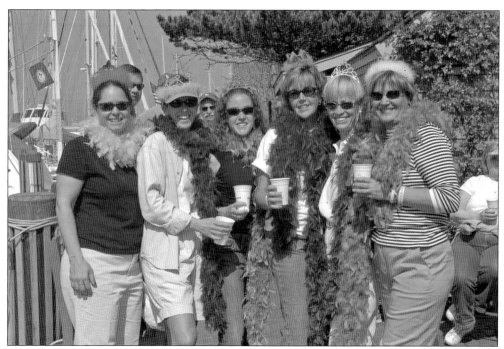

ROGER'S BLENDER IS READY! GIRLS ARE TOO! From left to right in boas are Deb Newson, Beth Duggan, Mackenzie Nurse, Patti Nurse, Jacquie Newson, and Jeannie Wallin. (Courtesy of Ed O'Neill.)

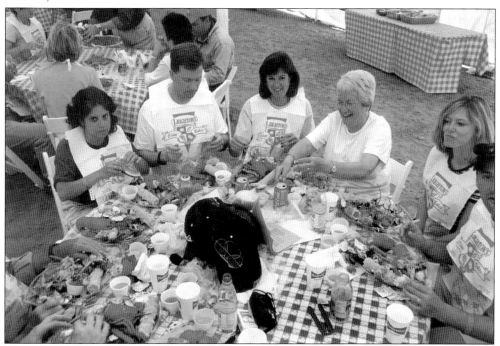

A FEAST EVERY YEAR. Here's an elevated view of a table of 12 enjoying the feast. The Leighton's Catering bibs even have instructions about how best to crack open the lobster. (Courtesy of Britt Crosby.)

SECONDS ON THE LOBSTER, 2004. John Burman and Diana Stinson of Sandwich, Massachusetts, enjoy a Figawi clambake with other members of the crew of the *Patricia J*, owned by Dan Hayes. Clambakes, prepared and enjoyed at the water's edge, are not necessarily "the norm" for sailboat regattas, which is why the Figawi clambake continues to be such an important part of this event. (Courtesy of Britt Crosby.)

LOBSTER AND CORN, 1982. Tony Prizzi came onboard Figawi in about 1975 and continues to serve on the Figawi Board of Governors. Chomping down on an ear of corn, Tony is pictured wearing his shades and his signature hat. The New England clambake was added in 1979 when Figawi officially became a three-day event. (Courtesy of the Figawi Archives.)

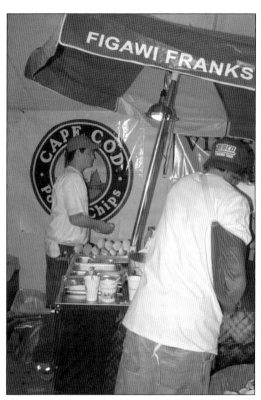

FIGAWI FRANKS. This young entrepreneur is capitalizing on "anything Figawi" as he promotes Figawi Franks outside the tent. (Courtesy of Britt Crosby.)

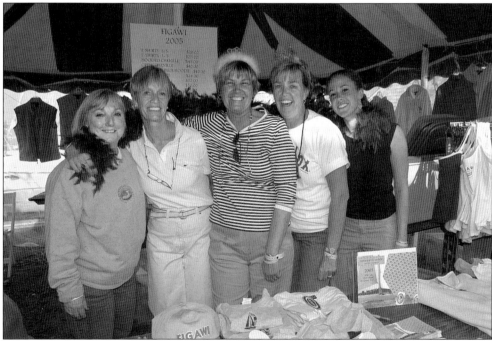

FIGAWI STUFF FOR SALE, 2005. Anything with the Figawi name or Figawi logo is hot stuff. It will all be sold before the end of the three-day weekend. Pictured are, from left to right, Ellen Zavatsky, Jacquie Newson, Jeannie Wallin, Patti Nurse, and Mackenzie Nurse. (Courtesy of Ed O'Neill.)

A TOAST. The three-day event is about sailing, but when the sun is down and dark draws near, it is time to party Figawi style. (Courtesy of Ed O'Neill.)

THE MCLAUGHLINS. Charlie McLaughlin and his wife, Nancy Noble, enjoy a light (Bud Light) moment in the Figawi tent. Charlie has been an integral part of this sailing event for over 30 years. (Courtesy of Ed O'Neill.)

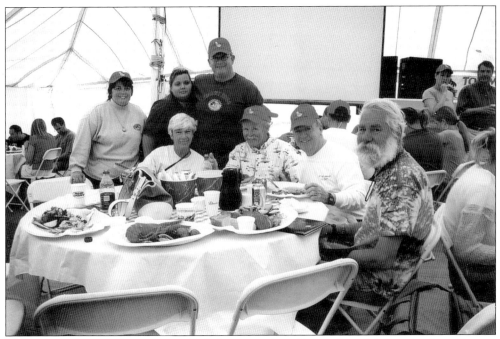

GOOD RACE, BETTER CLAMBAKE, 2004. Sitting at the table are, from left to right, Joyce Bearse, Bill Greer, Jim Dooley, and Mike Chilinski. Those standing are unidentified. (Courtesy of Ed O'Neill.)

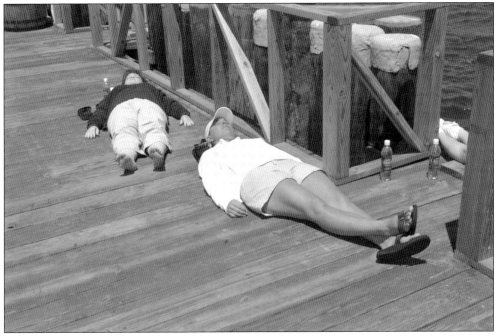

ALL TUCKERED OUT! It is not certain whether these two just got off the boat after a hard sail, are on a quest for a suntan or a quick nap, or perhaps recovering from the Figawi party. Whatever the reason, they look to be reasonably comfortable even on a hard wooden dock. (Courtesy of the Nantucket Police Department.)

Four

JOKE-TELLING SESSION

"If only he had been a better navigator, it never would have happened. But he wasn't, and it did. Jeffrey Carter Foster's *Anduril*, with its keel stuck firmly in the mud of the Nantucket Boat Basin, sat abeam of *Finn MacCool*, as they both spent a couple of hours awaiting the rising tide. Jokes, puns, poems, and of course insults were passed between crews and thus was born the Joke-Telling Session, now a mainstay of the Figawi Weekend," said Charlie McLaughlin and George Noonan in 1997.

"I came along about 1978, the first year I sailed on the old *Thorfinn* with John Osmond. Osmond introduced me to Jeff Foster and John Scott, and they invited me over to Grampus for mimosas the following morning after church. Along about 10:00 a.m., half in the chute, we started swapping stories. It was like the old radio show, *Can You Top This?* Soon a fair crowd pressed around Grampus and this, of course, just spurred us on. We finally brought down the curtain with Scotty Peatie's rendition of 'Eskimo Nell.' It was a foregone conclusion that we would meet again next year for a repeat performance," said Richard Anderson in 1988.

John Scott in 1986 explained: "According to *Webster's*, 'joke' means something not to be taken seriously, and 'session' means the ruling body of a Presbyterian congregation consisting of the elders in active service. Every Figawi Sunday, that congregation that is not taken seriously has convened on the balcony at Grampus, a cottage hangout on the Nantucket Wharf."

FOUNDER OF THE BAND OF ANGELS. John Scott once said as instruction to the Band of Angels, "All jokes are the same. It's the telling of them that takes the talent. Here now is your chance to see just how good you really are. Not some office-party, lampshade-wearing, heard-it-from-the-bartender joke. Can you best the best? Can you bring them to tears? Let the games begin." (Courtesy of the Figawi Archives.)

CARTER AT JOKE-TELLING SESSION (JTS), 1984. In 1988, the clapper, emblematic of induction into the Band of Angels, was bestowed upon Win Carter. This was the first time longevity alone was recognized and rewarded. Win successfully milked one joke ("Glazed Donut") for more years than anyone can remember. (Courtesy of the Figawi Archives.)

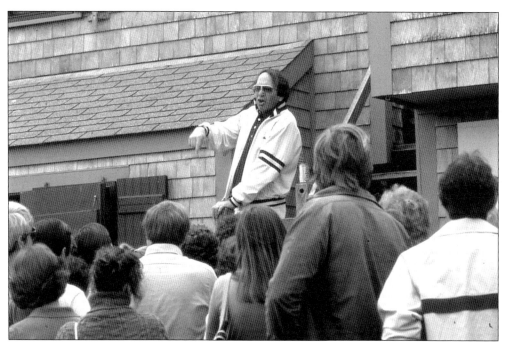

COTOIA, A CHARTER MEMBER. The Band of Angels (BOA) is the organizing force that kind of sponsors the JTS. They all chip in to buy about 25 cases of really extra-cheap champagne to serve at the joke session. Here, Al Cotoia, one of the four charter members, will do his version of "Such a Headache." According to Charlie McLaughlin, "Al has a voice like Sinatra's, and with Old Blue Eyes' departure, Al is now entertaining Las Vegas offers to perform at drive-through weddings and divorces." (Courtesy of the Figawi Archives.)

THE ONE AND ONLY JEFF FOSTER. Jeff Foster and his crew aboard *Anduril* were responsible for the first Joke-Telling Session back in 1977. Here, Foster is in the Figawi tent about to deliver his signature joke "Boris and Natasha." Other members of the Band of Angels, Scottie "Diesel Fitter" Peattie, Bob "Hey You" Hayden, Nick "Who's Kissinger Now" DiBuono, George "Foo Foo" Noonan, and John "Eskimo Nell" Scott, will follow. (Courtesy of the Figawi Archives.)

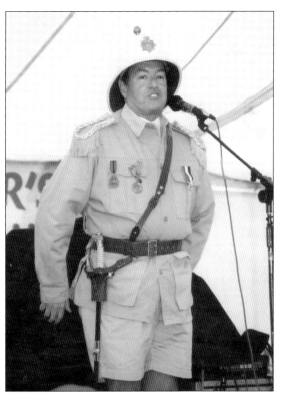

MCLAUGHLIN FRONT AND CENTER. The BOA members' names are engraved on the Band of Angels Clapperless Bell, which is on permanent display at Baxter's in Hyannis. Here, a uniformed Charlie McLaughlin, wearing his clapper, will eventually get around to telling his famous "Camel" joke (or maybe it is better known as "Sergeant Major"). (Courtesy of the Figawi Archives.)

A GOOD ONE! Judy Notz (with sunglasses around neck), a Figawi board member, laughs with everyone else at the Sunday morning joke session. Ever since the JTS was moved inside the Figawi tent, the crowds are bigger than ever, and it is a lot easier to serve the champagne. (Courtesy of Ed O'Neill.)

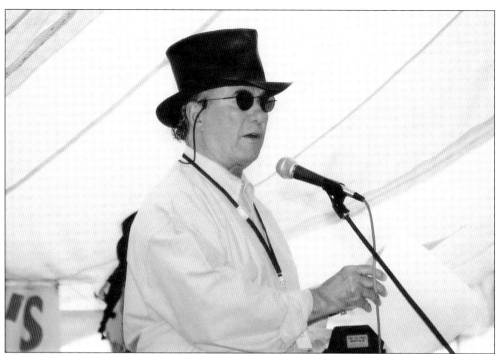

THE DOCTOR IS IN THE TENT, 2005. Dr. Tony Prizzi, out of his office and now on Figawi time, takes a turn at the Joke-Telling Session as he expounds his favorite story, all the while hoping that it brings the tent down. Here, he wears his own rather unique "Figawi hat," which is only seen during the race weekend on Nantucket. Dr. Prizzi is one of the longest serving members of the Figawi Board of Governors. (Courtesy of the Figawi Archives.)

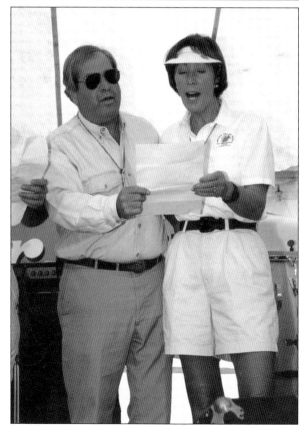

JOHN AND ELLYN OSMOND. The joke session was moved into the Figawi tent because tourists of all ages, arriving on the HyLine boat from the mainland, objected to some of the phrasing and innuendo emanating from the dock balcony. Here, Ellyn Osmond will offer her rendition of "Billy and the Train," and John Osmond will try his best to sing "Swing Low, Sweet Chariot." (Courtesy of the Figawi Archives.)

THE ANDERSON RULES. Dick Anderson got involved with the Figawi joke session back in 1978 when he sailed on *Thorfinn* with John Osmond. The following are the JTS rules as outlined by Anderson in 1990: no race, color, creed, or sex is safe from attack; no subject matter is off limits; a joke must be either a classic or fresh and funny; only members of the Band of Angels are permitted to tell classics; while a joke-teller may appear more than once, only one story per trip to the balcony is allowed; and the above rule is subject to change if, during the first trip, the teller is given the hook. Dick Anderson's classic joke was the story of "Hernando Red Gomez." (Courtesy of the Figawi Archives.)

BAND OF ANGELS SINGING THEME SONG, "SWING LOW." Current Band of Angels members include the following: Al Cotoia, Charlie McLaughlin, Nick DiBuono, Bob Hayden, John Osmond, Ellyn Osmond, Kristen Jensen, Tom Mullen, Euan Hutchinson, Missy Foster, Joanne Taupier, Jack DiRico, Paul Furze, Bill Riley, Cheryl Moulton, Lorraine Levine, Donny Levine, Dave George, Pete Bodycoat, Bob Haag, and Monique Vigeant. (Courtesy of Ed O'Neill.)

Five
WINNERS AND AWARDS

What is it that brings hundreds of sailors back to the Figawi Race each and every Memorial Day weekend? There are many reasons, but at the top of the list has to be the opportunity to win a Figawi trophy. It is often said that winning isn't everything, but it's very high on everyone's list.

Yes, there are the parties, and the weekend stay on an offshore island. It's a big-time reunion for people who see each other once a year; and a chance to be on the water and dance the night away in a tent on a beach on Nantucket. It's only 30 miles from home if you live on the Cape, but what a pre-season getaway before the touristas really start to descend.

The recognition of the winning skippers really started with John "Pie Plate Trophy" Linehan in 1973 and 1974. Aluminum pie plates, hand-painted with magic markers, were awarded to skippers for almost any unknown (except to Linehan) reason upon their arrival at Nantucket. Then as the event began to grow and develop more credibility, the Figawi Committee presented first, second, and third-place trophies in each division to all of the top performers. From 1975 to 1986, the names of the first-place winners were etched on the base of the original Figawi trophy. When the permanent trophy was commissioned in 1987, all of the division winners shared in the honor of being part of the Figawi trophy.

Over the years there have been a number of multiple winners, and there have been many who have considered it success to win once. Then there are the sailors who have fought the fight and have yet to experience the taste of victory. But all of them are thrilled, each time they head to the starting line, to realize what an important role they have played in the success of the Figawi Race.

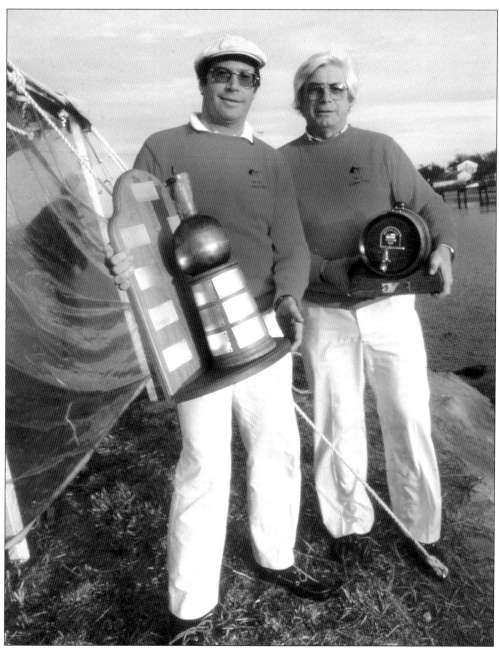

THE ORIGINAL FIGAWI TROPHY. Even though the race was only in its second year, the founders of Figawi decided it would be important for the winner to be awarded a trophy. So in 1973, Baxter's Boathouse bought the pewter wine decanter that was to become the grand prize of this event. Within a few years, however, there was no longer room to list any more winners on the decanter. John Magnuson of Centerville was commissioned to construct the finished teak trophy pictured here, and which is on permanent display at Baxter's. Joe Hoffman (left) is holding the trophy, with Howard Penn in charge of the Pusser's Rum Keg—out of which would soon flow "Pusser's Painkillers." (Courtesy of Figawi Archives.)

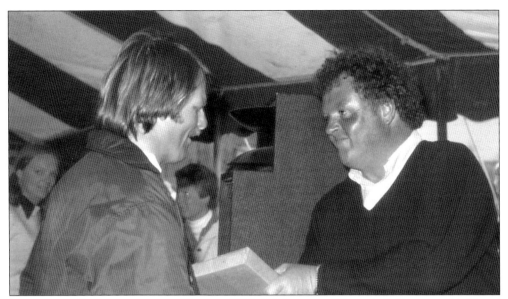

LAWSON AND *SKYSWEEPER* WITH A TROPHY, 1980. Bill Lawson of Hyannis (left) accepts his Figawi trophy from Bob Horan. Lawson successfully campaigned his sailboat *Skysweeper* in the 1980 race. (Courtesy of the Figawi Archives.)

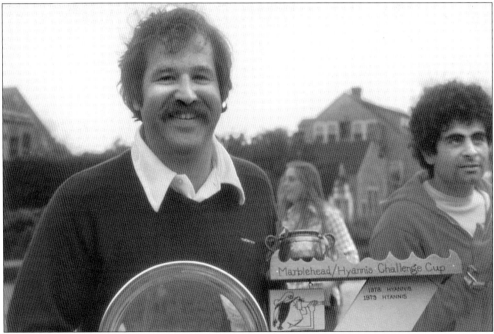

THE MARBLEHEAD TROPHY, 1980. The idea of a Marblehead/Hyannis Challenge Cup occurred to Jeff Foster and John Scott when they first came from Marblehead to Hyannis to race in Figawi. At that time Marblehead, Massachusetts, and Newport, Rhode Island, were considered to be the premier locations for competitive sailing in New England. Neither of them thought it would be very difficult to win going away on Nantucket Sound. But it was almost impossible. In 1980, the Hyannis team won the Marblehead Cup for the third time. Here, John Osmond holds the trophy as Wayne Kurker of Hyannis Marine looks on. (Courtesy of the Figawi Archives.)

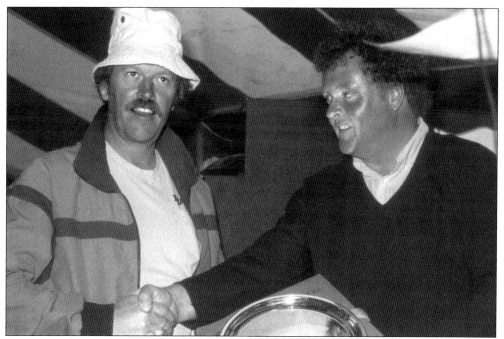

MCEACHRON A WINNER, 1980. Race committee chairman Bob Horan (right) presents a winner's trophy to Peter McEachron in 1980. McEachron sailed *Flyway* to a first-place finish in the Class C competition. (Courtesy of the Figawi Archives.)

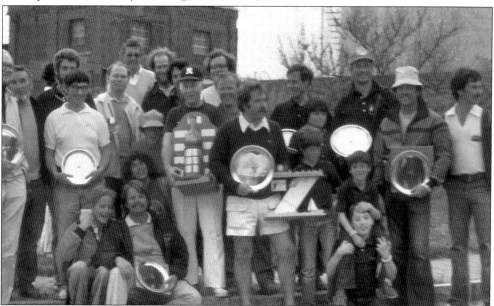

FIGAWI WINNERS, 1980. The 1980 winners, seen with the original Figawi trophy in Nantucket, included: Class A *Thorfinn* sailed by John Osmond; Class B *Loose Goose*, Mike Frigard; Class C *Flyway*, Peter McEachron; Class D *Tin Horn*, Chuck Gordon; Class E *Reflexion* sailed by Paul Foraste; Class F *Point After* skippered by Tom Tipton; Class G *Morpheus III*, Ben Walcott; Class H *Noel* sailed by Herb Cahoon; and the Streaker winner *Mavourneen* with Sally Serpico at the helm. (Courtesy of the Figawi Archives.)

THE LINEHAN TROPHY, 1982. Jack Payntar is presented with a now-famous John Linehan pie-plate trophy. John would use Magic Markers to create his own awards on aluminum pie plates. This one reads, "Figawi 1982, the Non-Support Award," and at the bottom it has a fleet of sailboats, presumably sailing to Nantucket. (Courtesy of the Figawi Archives.)

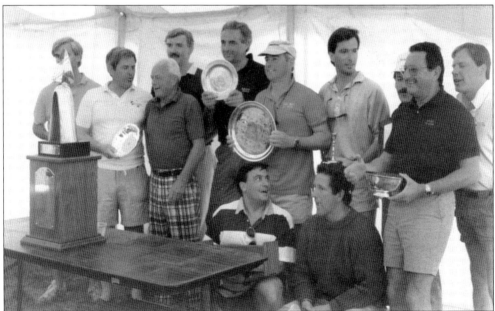

FIGAWI WINNERS, 1988. From left to right are Wiley Wakeman of *Wild Goose* (behind Figawi trophy); Cy and Gordon Nelson of *Bellatrix*; John Holloway (behind Nelson) of *Counter Point*; Bob Cicchetti of *Defiance*; Chuck Howard of *Shockwave*; Mike Bello (below Howard) of *Mogul Bandit*; Barry Sturgis of *Black Fin*; Ron Sears (below Sturgis) of *Cherokee*; Greg Kelly of *Speculation*; Marvin Rosen of *Magic*; and Tom Duggan of *Mogul Bandit*. (Courtesy of the Figawi Archives.)

PAMELA TRUSSELL DUGGAN (MAY 7, 1958–FEBRUARY 14, 1989). G.D. Prentice wrote: "People who have warm friends are happier and healthier than those who have none. A single real friend is a treasure worth more than gold. Money can buy many things good and evil. All the wealth of the world could not buy you a friend or pay you for the loss of one." Three months after those words were spoken at Pam's memorial service, the Figawi Board of Governors presented the first Pamela Trussell Duggan Special Recognition Trophy, awarded each year thereafter to those who have made outstanding contributions to the Figawi Race.

JUDY NOTZ IS A WINNER, 1995. Jacquie Newson on the left is making the presentation of the Pamela Trussell Duggan Special Recognition trophy to Judy Notz in 1995. Judy has worked with Figawi for many years. She is a member of the Figawi Board of Governors and also is the editor-in-chief of the Figawi program book. (Courtesy of Ed O'Neill.)

FIGAWI WINNERS, 1998. The 1998 winners pose with the permanent Figawi trophy in Nantucket. Class A *Spice* sailed by Arthur Burke; Class B *Affinity*, Jack Desmond; Class C *Dreamer*, Jim Flanagan; Class D *Nepenthe*, Robert Read; Class E *Kiwi*, Ian McNeice; Class F *Robert Emmett*, Richard Finnin; Class G *Defiance*, Robert Cicchetti; Class H *Camelot*, Robert Labdon; Class K *Primrose*, Donald Liptack; Class L *Isabel J.*, Andrew Keturakis; Class S *Letter of Marque*, Douglas Halsted; and Class T *Heritage*, Jeffrey Barrows. (Courtesy of Ed O'Neill.)

CICCHETTI AGAIN, 1998. Bob Cicchetti is pictured here being presented with the winner's trophy in 1998 from board members Dennis Sullivan and Fred Scudder. Bob, sailing his 1927-vintage, 42-foot Crosby yawl *Defiance*, was the Best in Class in 1987, 1988, 1989, 1991, 1993, 1994, 1998, 2000, 2003, 2005, and 2009. The only other 11-time winner in the first 41 years of Figawi racing is Charles Prefontaine and his sailboat *Helios*. (Courtesy of Ed O'Neill.)

THE HERRESHOFF MARINE MUSEUM TROPHY. This trophy is awarded to the most competitive boat in the racing and cruising divisions. It was donated by Michael Deeley of Osterville to honor the outstanding efforts of Halsey Herreshoff and Herreshoff Marine Museum in Bristol, Rhode Island, in preserving the history of New England's premier yacht builders and yachtsmen. Here, the trophy is presented to Joe O'Neal, the owner and skipper of *Banshee*. (Courtesy of Britt Crosby.)

PREFONTAINE A BIG TIME WINNER, 2004. Charles Prefontaine, shown here with his wife, Nancy, holds the 2004 winner's trophy for Division N, and that's not even the half of it. Charlie has sailed *Helios* to victory 11 times in the race from Hyannis to Nantucket. He also has a few trophies for the return race to the Cape, a couple of Herreshoff Marine Museum trophies, and at least two Jeffrey Carter Foster team trophies with the group representing the Mattapoisett Yacht Club. (Courtesy of Ed O'Neill.)

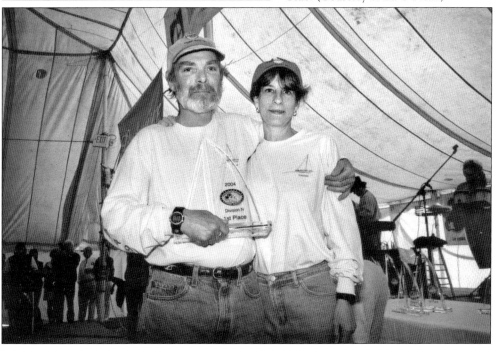

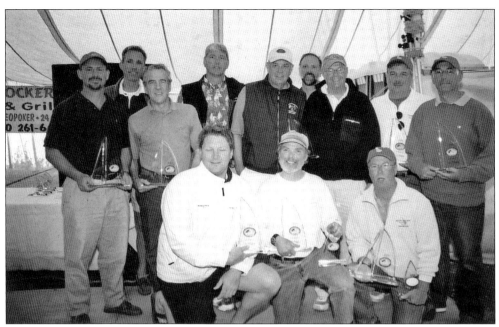

"AND THE TROPHY GOES TO," 2004. The winners of the 2004 trophy were as follows: Class A, Blair Brown sailing *Sforzando*; Class B, Jeff Rabuffo on *Xenophon*; Class C, Tom Purcell on *Moondog*; Class D, Bill Abbott with *Allaura*; Class E, John Mollicone sailing *Flashpoint*; Class F, Bob Warren onboard *In Deep*; Class G, Tom Hall on *Chloe Nicole*; Class H, Tom Tetrault with *Facet*; Class K, Paul Blum sailing *Blue Note*; Class L, Peter Soule on *Saylavee*; Class M, Donald Liptack with *Primrose*; Class N, Charles Prefontaine sailing *Helios*; and Class T, J.C. Raby with *No Decorum*. (Courtesy of Ed O'Neill.)

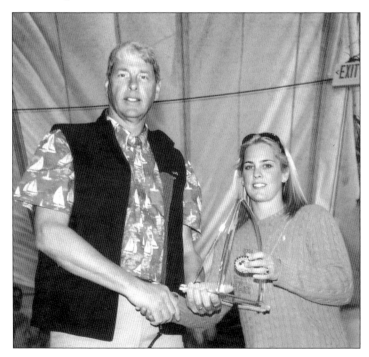

TOP DOG IS MOONDOG, 2004. Figawi board member Shelley McCabe presents the 2004 first-place trophy in Class C to Dr. Thomas E. Purcell. Purcell is the owner and skipper of a C&C 115 sailboat named *Moondog*. All of the various class winners are presented with keeper trophies at the awards ceremony held each year in the Figawi tent. It has always been the Figawi tradition that each of the class winners shares equally in winning the permanent Figawi trophy. (Courtesy of Ed O'Neill.)

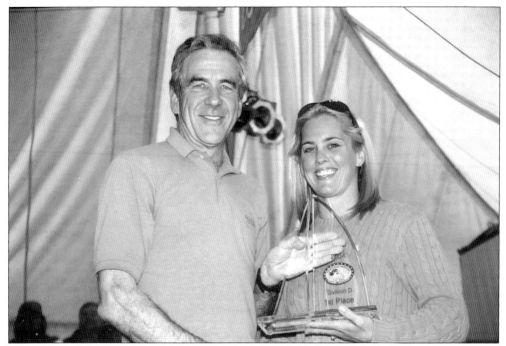

WINNER ABBOTT, 2004. Bill Abbott takes the 2004 Class D trophy from Shelley McCabe, after he sailed *Allaura* to a first-place finish. Abbott would also win in 2007. Shelley McCabe is the new executive director for Figawi Inc. (Courtesy of Britt Crosby.)

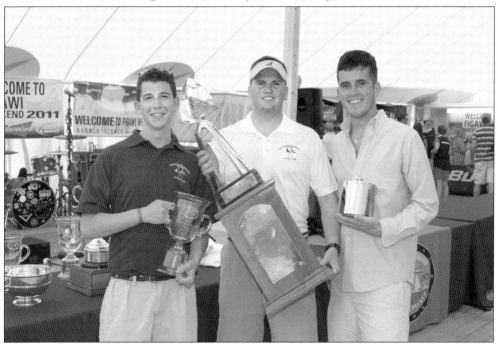

MMA TOPS THE FLEET, 2011. In 2011, the Massachusetts Maritime Academy sailing team took first-place honors in Class A. Team representatives are pictured here after sailing *Natalie J*, a Nelson Merek 46-footer, to Nantucket for the win. (Courtesy of Britt Crosby.)

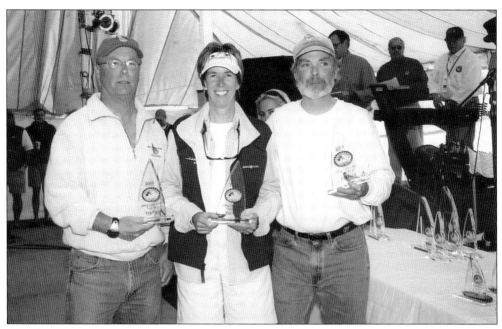

TEAM TROPHY WINNERS, 2004. The Jeffrey Carter Foster Team trophy winners are, from left to right, Bob Warren, sailing his boat *In Deep*; Beth Duggan, representing John Downey and *Gambler*; and Charles Prefontaine, with his boat *Helios*. All are representing the Mattapoisett Yacht Club. (Courtesy of Ed O'Neill.)

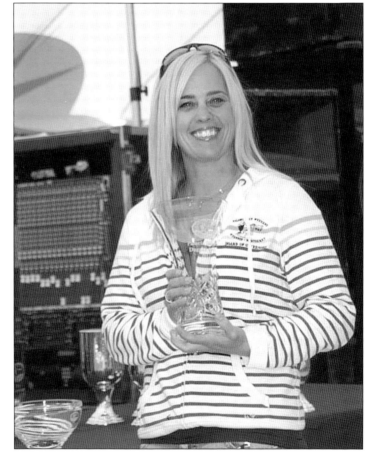

PAMELA TRUSSELL DUGGAN SPECIAL RECOGNITION TROPHY, 2002. The Pamela Trussell Duggan Special Recognition trophy in 2002 went to Shelley McCabe. (Courtesy of Ed O'Neill.)

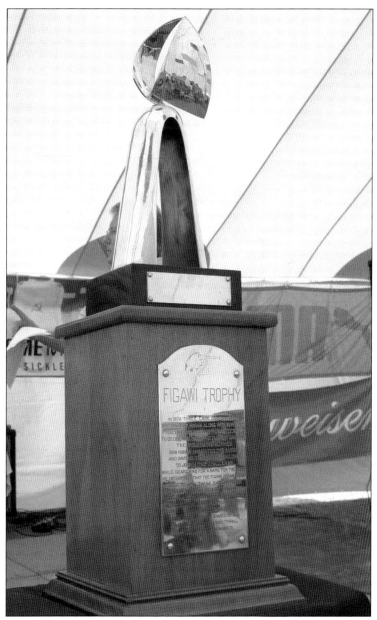

FIGAWI RACE TROPHY. Neil Terkelson, a silversmith in West Barnstable on Cape Cod, presented the permanent Figawi trophy to the Figawi Race. The trophy came about with the help of Jeff Buddington and the generosity of the Guertin Brothers Jewelers of Hyannis. In 1987, the Guertins donated this beautiful trophy reflecting Figawi's status as one of sailing's major events on the east coast. Terkelsen's design sought to capture the power and drive of a taut sail, hard on the wind. The boat is sailing on an arc of silver, representing the ocean connection between Hyannis and Nantucket. The silver rests on a large base made of solid teak. On the front of the base is a silver plate that offers a short history of the beginnings of the Figawi Race. Terkelsen spent 70 hours building the three-and-a-half-foot award. This handsome trophy is an appropriate recognition of the talents and teamwork of the skippers and crews. The permanent trophy is on display at the Captain's Table at the Hyannis Yacht Club. (Courtesy of Britt Crosby.)

Six

FIGAWI CHARITY BALL

In 1987, the Figawi Committee embraced the idea of a black-tie fundraiser to be held in Hyannis a week prior to the race to Nantucket. Joe Hoffman sold the concept of a charity ball to his fellow board members, so that Figawi would have a vehicle to raise thousands of dollars for local Cape Cod charities.

So off it went. Dennis Sullivan, Skip Scudder, and other board members were on ladders hanging decorations at the old Cape Codder Hotel, under the watchful eyes of Sue Fein and Felicia Penn. These two ladies spent time gathering beach grass for decorations—and in the meantime, hiding from anyone passing by. Tickets were only sold to those who would attend. Food was donated from the surrounding restaurants and cooked and served by the hotel staff. Flowers came donated by local florists. John Salerno's Big Band Sound played all night and did not charge a cent. The raffle and casino were introduced as moneymakers for the first charity recipient, the YMCA. The smell of mothballs permeated the air as not many folks had worn a tux or fancy dress in so long that they had to dig them out of the attic. And that first year, the ticket price was only $10. It was the beginning of what has become a great event. After more than 25 years, it is the most successful night of fundraising on Cape Cod. To date, Figawi has raised well over $3 million in support of local charities. As the promotion says, "FIGAWI, it's more than just a race!"

—Leo Fein

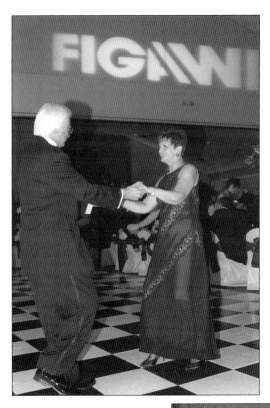

HOWARD AND BETTY PENN DANCING THE NIGHT AWAY, 1998. In 1987, the Figawi Charity Ball began its run as one of the most successful nights of fundraising on Cape Cod. The whole concept was to keep all expenses next to nothing, charge a $10 ticket price to attend, and give all of the proceeds to charity. It worked, but it was only possible with the help of a lot of volunteers. (Courtesy of Ed O'Neill and Leo Fein.)

THE VERY FIRST FIGAWI BALL, 1987. Joe Hoffman and Felicia Penn love every minute of it as the first Figawi Ball gets started, and its success seems to be assured. As a downbeat, bandleader John Salerno promised Joe and Felicia he would perform "In the Mood," their big-band favorite. (Courtesy of the Figawi Archives.)

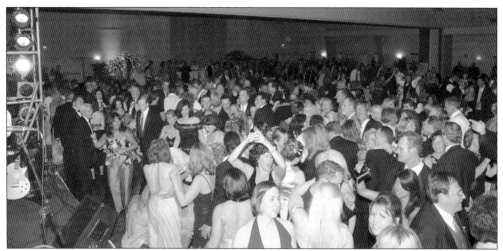

A Party, 2005. The whole idea is to have a lot of fun and raise a lot of money for Figawi charities. It seems here in 2005 that the goal has been accomplished, and then some. To date, the Figawi Ball has benefited over 150 local charities. As Leo Fein says, "Help us keep giving to the community by coming back every year." (Courtesy of Britt Crosby.)

McGillen in Kilt, 1998. Dorothy "Dottie" and James "Jimmy" McGillen attend one of their many Figawi Balls in 1998. It is this kind of support that has made this event what it is today. And it gives those who may not be any longer up to the crash-and-burn race activities a way to still be a big part of Figawi. (Courtesy of Ed O'Neill.)

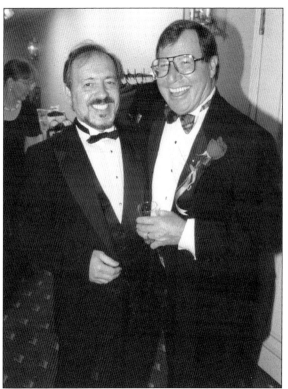

"Maestro, If You Please," 1987. John Salerno (left) is pictured with Joe Hoffman at the very first Figawi Charity Ball in 1987. John was a high school music teacher and band director and had met Joe in Canton, Ohio, in 1968 while he was on tour. Here on the Cape he led a 14-piece orchestra that played a big-band sound. Salerno and all of his musicians donated their time and talent that night so that the ball would be a success. (Courtesy of the Figawi Archives.)

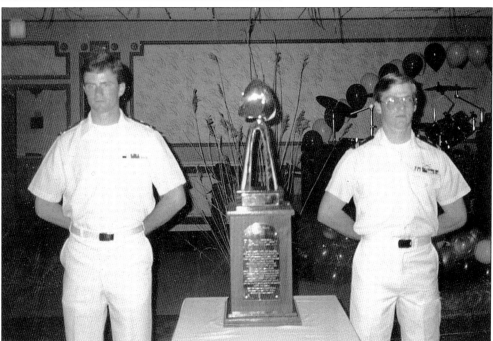

On Guard with the New Permanent Trophy, 1987. It was at the first charity ball that the brand new Figawi trophy was put on display. Figawi had asked these cadets from the Massachusetts Maritime Academy to stand as honor guards. (Courtesy of the Figawi Archives.)

SILENT AUCTION AT FIGAWI BALL, 2005. Here, one will likely find artwork, floral arrangements, restaurant certificates, sporting event tickets, rounds of golf, jewelry, vacation getaways, cruise line trips, boat models, autographed Patriots footballs, Red Sox baseballs, Celtics basketballs, certificates for health clubs and a "day of beauty," and much more. The auction, the raffle, and the casino gambling go a long way toward filling the coffers of Figawi Charities. (Courtesy of Ed O'Neill.)

MERELY A MATTER OF PERFECT ATTENDANCE, 2005. Richards French and his wife, Susan, are seen here in 2005. Dick and Susan have regularly volunteered to help out in many capacities at the Figawi Ball and have a perfect attendance record. (Courtesy of Ed O'Neill.)

TICKETS FOR SALE, 2006. Jacquie Newson is hustling people to buy raffle tickets at the Figawi Charity Ball in 2006. Jacquie came onboard with Figawi way back in 1977 as an assistant to Bob Horan. She has done everything she could have done on behalf of this organization and, as seen here, is still trying to raise money for Figawi. (Courtesy of Britt Crosby.)

BLACKJACK, 2010. Dee Petrillo is dealing at this blackjack table during the 2010 Figawi Ball. All of the players here seem intent on beating the house and taking home a few shillings. But if it does not work out that way for them, they do not really care. It is all going to a good cause. And if they have no luck with Dee, there is always the roulette wheel or the craps table. (Courtesy of Britt Crosby.)

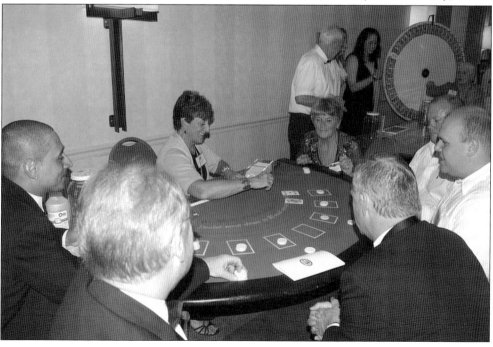

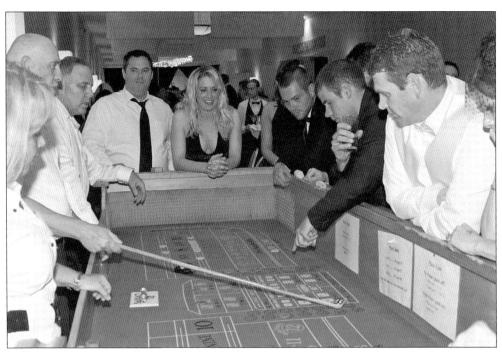

A CRAPS TABLE AT THE BALL, 2008. A raffle and casino were introduced as moneymakers in the first year of the ball and today go a long way to make the Figawi Ball the biggest one-night fundraiser on the Cape. The very dedicated volunteers who plan and man this great event are part of the magic. (Courtesy of Britt Crosby.)

LONGTIME CO-CHAIRS, 2005. Leo and Susan Fein, who have been in charge of the Figawi Charity Ball since its inception, announced their retirement this year after 20 years of guiding the event to its pinnacle of success. They now turn the event over to Chris and Rebecca Standish, who have an established and seasoned Figawi Charity Ball Committee and a boatload of volunteers to back them up. Leo and Susan deserve this last dance. (Courtesy of Ed O'Neill.)

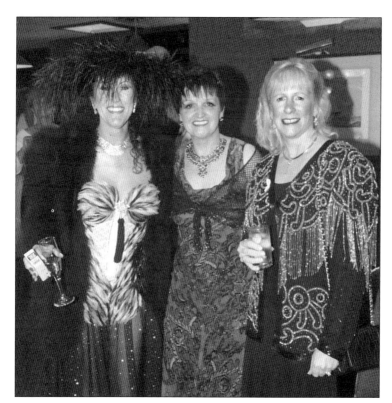

LADIES' NIGHT OUT, 2005. From left to right, Mary Ellen Prizzi, Betty Penn, and Judy Notz do it up right at the Figawi Ball in about 2005. Every year, Mary Ellen seems to be about wearing a gown that outdoes the one from the year before. And every year, without fail, she succeeds. (Courtesy of Ed O'Neill.)

HAVING A BLAST AT THE BALL, 2005. It is just the "Sturgis Gang of Six," out for a good time at the Figawi Ball. Pictured are, from left to right, (sitting) Nicole Sturgis and Diane Alfano; (standing) Barry Sturgis, Craig Ashworth, and Peggy Ashworth. Stretching out across two laps is Jane Douglas. (Courtesy of Ed O'Neill.)

STANDISH TAKING THE REINS. Chris Standish, shown here at the microphone at the Figawi Ball, assumed the job of chairman of the Figawi Charity Ball Committee after Leo and Susan Fein stepped down. (Courtesy of Ed O'Neill.)

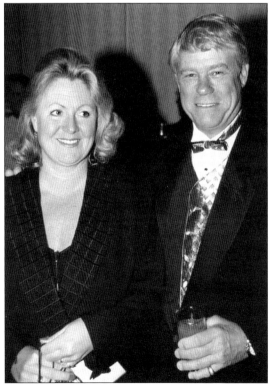

BODENS AT THE FIGAWI BALL, 1998. Fred and his wife, Candice Collins-Boden, are "in the house" at the 1998 Figawi Ball. Fred was a board member for over 20 years and served as patrol boat chairman and then as the first editor of the Figawi program book. (Courtesy of Ed O'Neill.)

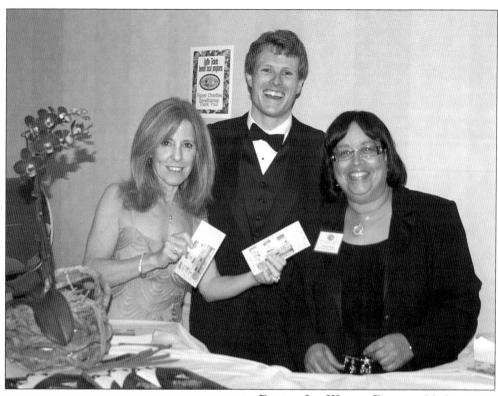

Donna, Joe III, and Deanne, 2010. Donna Nightingale (on the left) is sorting out some tickets for Joseph Kennedy III and Deanne Maraj at the Figawi Ball in 2010. Donna has been a part of the Figawi Charity Ball Committee since its inception and is a sitting member of the Figawi Board of Governors. As of this writing, Joe Kennedy is the newly elected congressman from the 4th District of Massachusetts. Deanne is an executive with the Cape Cod Hospital, one of the big beneficiaries of Figawi Charities, and a longtime ball supporter. (Courtesy of Britt Crosby.)

The Feins at Cape Cod Hospital, 2002. Leo and Susan Fein visit the John F. Kennedy Jr. Pediatric Unit at the Cape Cod Hospital in 2002. Every cent raised from the ball goes to local Cape Cod charities. By 2012, over $3 million has been raised to benefit 150 local charities. Figawi is proud of helping build the pediatric wing, as well as a suite at the Mugar Tower of the Cape Cod Hospital. (Courtesy of the Cape Cod Hospital.)

Seven
FRIENDS OF FIGAWI

During all these years, sailors and crew from all over New England and beyond have supported the Figawi Committee. There have been countless numbers of volunteers who have helped out each and every time they were asked. Elected officials on the Cape and over on Nantucket Island have worked with Figawi as has the press, the business community, and the public at large. Those are the people referred to as Friends of Figawi. Many of them—but not all—are pictured in the following pages.

IN CHARGE AT NANTUCKET. Joe Lopes was dockmaster at the Nantucket Boat Basin when Bob Horan started the Figawi Race. George Bassett, on the right, took over the Wharf area when Lopes retired. (Courtesy of Britt Crosby.)

FIRST FIGAWI WEDDING. Mr. and Mrs. William "Billy" F. Moore were married on Figawi Race Weekend in 1994. Pictured here a few years later, Billy and Mary Beth look as if their wedding were only yesterday. Billy is the part-owner of Spanky's Clam Shack on the Hyannis Ocean Street docks and a loyal supporter of the Figawi Race. (Courtesy of Figawi Archives.)

EARLY-ON FIGAWI FANS. Pictured are, from left to right, (first row) Keran Lockhart, Chuck Lockhart, and Donna Baker; (second row) Morris "Mo" Johnson, Ted Clifton, and Bob Baker. (Courtesy of Figawi Archives.)

MR. AND MRS. FIGAWI, 2008. David and Monique Crawford are pictured on Nantucket in 2008. David is the chairman of the Figawi Board of Governors and has held that position since 2002. Under David's leadership, and following on the efforts of his predecessors, the Figawi Race is probably the biggest and best-attended regatta sailed on an annual basis in the United States. (Courtesy Ed O'Neill.)

WHICH ONE IS A WIG, 1977. Pictured on the left is Howard Penn, wearing his own white hair, with Keran Lockhart on the right, wearing . . . a pink wig? Just about anything goes on the Nantucket docks during Figawi Race Weekend. (Courtesy of the Figawi Archives.)

FRED SCUDDER, 1983. Fred Scudder, it seems, was born to be on the water. His father, Bob, and his Uncle Dick bought a couple of sightseeing boats (*Patience* and *Prudence*) to take tourists out to see the Kennedy compound. After they added a few ferryboats, people could go to Martha's Vineyard and Nantucket on what is now known as the HyLine. Fred learned about Figawi as it was beginning and became involved as a racer and then as a board member. Here he is at the skippers' meeting in 1983 at the Hyannis Yacht Club. (Courtesy of Ed O'Neill.)

JOHN T. GRIFFIN JR. It seems as if he has always been here, and maybe he has. Griff is Figawi through and through. He was a winner in the B Division way back in 1974 when he was sailing *Mooncusser*. He was at most of the races and maybe all of them. He jumped at the chance to spread the word about the Figawi Ball. A bigger fan of Figawi does not exist. (Courtesy of Vince Dewitt and the *Cape Cod Times*.)

ALL WORK AND SOME PLAY, 2004. Official Figawi photographer Britt Crosby and Robyn Crosby from Osterville relax for a bit on Nantucket in 2004. When he is not shooting Figawi pictures, Britt is a paramedic with the Centerville–Osterville–Marston Mills fire department. His wife, Robyn, is a firefighter dispatcher in Barnstable, Massachusetts. (Courtesy of the Figawi Archives.)

THE TENT AT NANTUCKET, 1998. From left to right, Ray Kittila, Sharon Bassett, and Alice O'Neill are in the Figawi Tent following the race in 1998. The winners were Arthur Burke, Jack Desmond, Jim Flanagan, Robert Read, Ian McNeice, Richard Finnin, Robert Cicchetti, Robert Labdon, Donald Liptack, Andrew Keturakis, Douglas Halsted, and Jeffrey Barrows. (Courtesy of Ed O'Neill.)

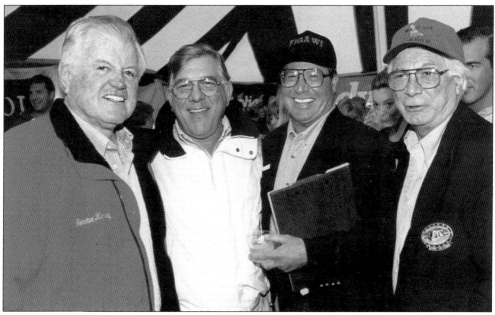

THE SENATOR IN THE TENT. From left to right, Sen. Ted Kennedy, Jim Hegarty, Joe Hoffman, and Howard Penn meet in the Figawi Tent in about 1989. (Courtesy of Ed O'Neill.)

CO-CHAIRPERSONS OF THE FIGAWI BALL. Chris and Rebecca Standish now share the duties of running the Figawi Charity Ball, as they do in their other life as husband and wife. (Courtesy of Britt Crosby.)

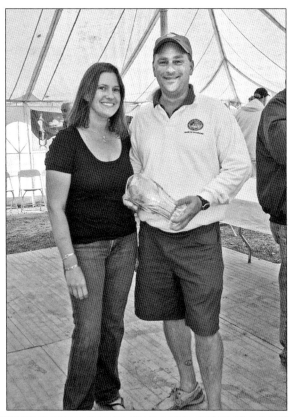

A TOAST OF MOUNT GAY RUM, 2004. Joyce Bearse and Jim Dooley hoist a glass as they celebrate the fun at Figawi Race Weekend. Joyce is crew on Dooley's boat. Pay attention to the famous Figawi/Mount Gay red cap that Jim is wearing. These caps are dated with each year of the race, and they are very similar to Mount Gay hats at other regattas. Therefore, to see this cap at sailing venues all around the world is not surprising. (Courtesy of Ed O'Neill.)

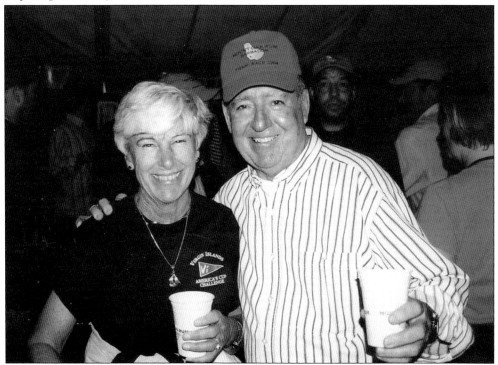

LAUGHING IT UP WITH BILLY GREER, 2004. It is hard to imagine anybody having more fun at the Figawi party than Bill Greer does. He comes to Nantucket every year. (Courtesy of Ed O'Neill.)

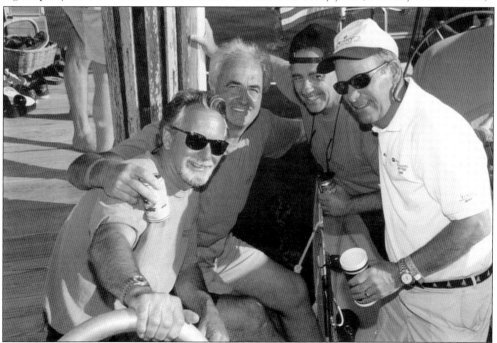

SOME SKIPPER TALES, C. 2000. From left to right, owner of *Affinity*, Jack Desmond; owner of *Defiance*, Bob Cicchetti; unidentified crew member on *Affinity*; and finally Stan Moore are pictured. (Courtesy of Ed O'Neill.)

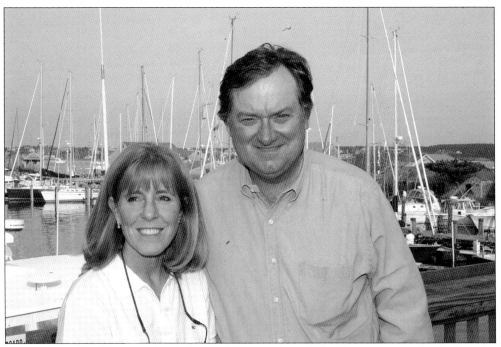

DONNA WITH TIM RUSSERT, 2005. Donna Nightingale and Tim Russert are on the deck at the Nantucket Anglers Club, with the boat basin in the background. (Courtesy of Ed O'Neill.)

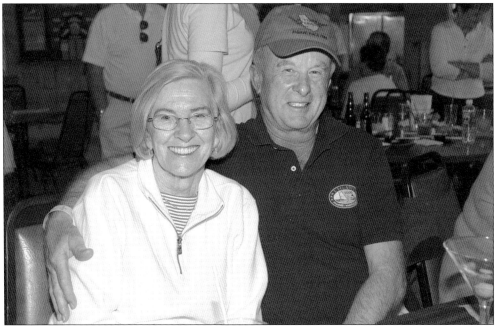

BIG SUPPORTERS OF FIGAWI IN THEIR OWN WAYS, 2005. Mary LeClair and Jim Fox are pictured here at the Nantucket Anglers Club in 2005. Mary was an integral part of the support team for Betty and "Howie Figawi" Penn during his final illness. Jim Fox was the captain of the tugboat *Towline* out of the Massachusetts Maritime Academy, which served as part of the patrol boat fleet for many Figawi Race Weekends. (Courtesy of Ed O'Neill.)

ED AND HIS WOMEN, 2005. The Figawi photographer Ed O'Neill is pictured on somebody's boat in Nantucket Harbor. Ed is surrounded by family and female friends, all helping him enjoy his retirement. (Courtesy of the Figawi Archives.)

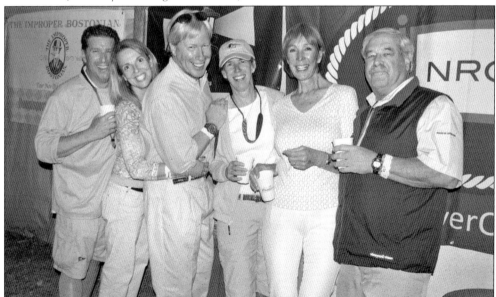

ROGUE GROUP OF FIGAWIERS. From left to right are Donny and Lorraine Levine, Tom and Beth Duggan, and Ellyn and John Osmond. Lorraine Levine has been for many years and still is a part of the Figawi Charity Ball Committee. Tom Duggan is the principal race officer for the Figawi Race, a position he has held for years. Ellyn Osmond has been telling stories (or jokes) for a long time as a member of the Band of Angels, and John has been a member of the Figawi Board of Governors since inception. He first started to help promote the race back in 1973 and is still one of the primary Figawi movers and shakers today. (Courtesy of Figawi Archives.)

THE FEINS AND PENNS AT NANTUCKET ANGLERS, 2005. From left to right are Leo and Susan Fein with Betty and Howard Penn at the Nantucket Anglers Club in 2005. (Courtesy of Ed O'Neill.)

GEORGE, TIM, AND ROZ AT THE ANGLERS CLUB, 2005. George Graeber and his wife, Rosalind, visit with Tim Russert at the Anglers Club in Nantucket. George has been defined as someone who has been around Figawi for a long time and would do anything that was asked of him if it would help. (Courtesy of Britt Crosby.)

QUIET AND UNSUNG. Milton Salazar has been a part of the Figawi Race since at least 1979 and maybe before. He is a longtime member of the board and does about anything that people ask him to do. He misses his good friend Howard Penn, as all of Figawi does. (Courtesy of Ed O'Neill.)

CREW OF *STRAIGHT JACKET*, 2005. The *Straight Jacket* crew poses for a picture on the beach in front of the Hyannis Yacht Club in 2005. For years, sailors have been coming to the HYC clubhouse on Friday night, where they get their skipper bags that hold scratch sheets, tent entry bracelets, slip assignments, a racing pennant, Mount Gay caps, a sponsors' T-shirt, and about anything else that the committee wishes to distribute. (Courtesy of Ed O'Neill.)

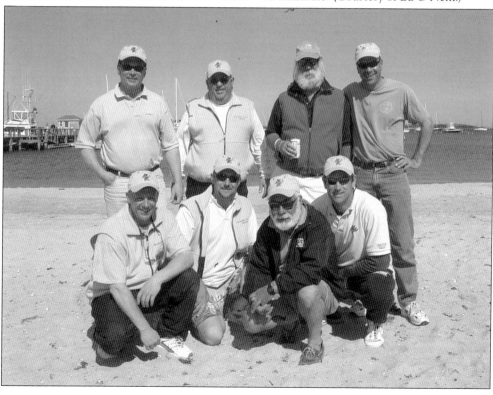

SOME BRASS AT HYC, 2005. From left to right are George Bassett, Vicki Kennedy, Sen. Ted Kennedy, David Crawford, and Bob Haag. (Courtesy of Ed O'Neill.)

LONGTIME FIGAWI FRIENDS. Pictured here are George Bassett (on the left) and Howard Penn. (Courtesy of Ed O'Neill.)

JACQUIE NEWSON AND PAMELA DUGGAN, MID-1980s. Vibrant, beautiful, fun-loving, hardworking, a go-getter, outstanding smile, member of the board, and everyone's good friend—all described Pam (pictured at right). (Courtesy of the Figawi Archives.)

PAMELA TRUSSELL DUGGAN. A member of the Figawi Board of Governors and a friend to everyone she met, Pam's untimely passing on February 14, 1989, is still felt by all who knew her. In Pam's memory, a special recognition trophy is presented each year to a most deserving person connected to Figawi. (Courtesy of the Figawi Archives.)

Eight
PROGRAM BOOK AND OTHER TREASURES

The first Figawi program book was produced in 1984. It was a landmark decision by a group of people who understood that for the race to grow and prosper, it had to present itself as legitimate, high-quality, progressive event open to all levels of sailing expertise. It needed a marketing tool that could raise both awareness and revenue and provide the avenue to ask sponsors for financial help. The program book did all of that.

Beginning in 1993, the board asked a local artist each year to create an original painting that could be sold at the Figawi Charity Ball to raise funds for Figawi Charities Inc. To date, some of the most prominent marine artists on Cape Cod and the islands have contributed their talents to this effort.

Fred Boden was the program book editor from the beginning and did a masterful job for a guy who was not in the publishing business. He was followed by Judy Notz, and the two of them have set the bar for years to come.

Also in this chapter, one will find some "stuff" that is important to the understanding of the Figawi Race; however, the information did not fit nicely anywhere else in the book. This is a catch-all chapter.

THE FIGAWI PROGRAM BOOK AND ITS COVERS. This collage of program covers, which starts with the first book in 1984 and continues to 2011, reflects the Figawi dedication to a better event, year after year. (Courtesy of the Figawi Archives.)

THE FIGAWI ARTISTS. *1999 Figawi Race* by Sam Barber is an example of the original works that the area's best marine artists have generously contributed to the Figawi Charity Ball auction and the Figawi program book for the past 20 years. Other artists included Geoffrey Smith, 1993; Karen Fitzgerald, 1994; Nancy Braginton-Smith, 1995; John Richardson Woodruff, 1996; William R. Davis, 1997; Elizabeth Mumford, 1998; William G. Muller, 2000; Peter Quidley, 2001; Jayne Shelley-Pierce, 2002; Robert E. Kennedy, 2003; Susan O'Brien McLean, 2004; Frederick Collard, 2005; Neil McAuliffe, 2006; Julia O'Malley-Keyes, 2007; Lance Walker, 2008; Matthew Schulz, 2009; Russell Vujs, 2010; Jerome Howes, 2011; and Marjorie Mellor, 2012. (Courtesy of the Figawi Archives.)

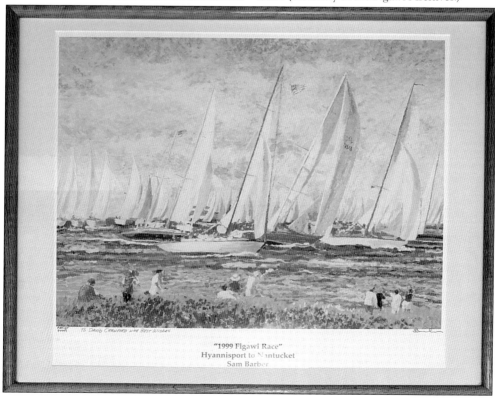

FRED AND ED, 1980s AND 1990s. Fred Boden (left) joined the Figawi Committee in 1981 and took charge of publishing the Figawi program book on its inception in 1984. Fellow board member Charlie McLaughlin said of Fred, "He was exacting in his attention to the design and content of the book and worked closely and professionally with Figawi's earliest sponsors to provide them with exposure to our participants." Fred published the program book until 1991, when he turned it over to Judy Notz, with whom he had worked for many years. Fred retired from the board in 2001 and passed away in March 2011. Ed O'Neill (right) a retired official Figawi photographer, passed away in March of 2013. (Courtesy of the Figawi Archives.)

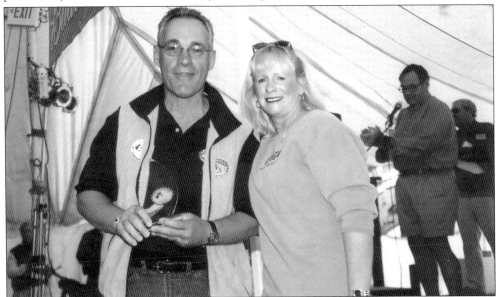

FIGAWI BOOK TEAM, 1980s, 1990s, AND BEYOND. Dick Vecchione and Judy Notz are seen here at the Figawi Tent in 1998. Dick was responsible for the art design, layout, and production of the Figawi program book from 1984 until 2004. He worked very closely with Fred Boden and then, of course, followed through with Judy Notz to make sure that the book was always the quality product that the board expected. Judy continues to publish the book, which this year produced its 29th edition. (Courtesy of Ed O'Neill.)

WILLIAM G. MULLER, 2000. Bill Muller is one of America's preeminent maritime historical artists. Inspired during his childhood years growing up in New York City near the Hudson River where he watched the busy shipping traffic, Bill was especially enticed by the majestic old side-wheel river steamboats that were still plying the Hudson back then. He studied at Pratt Institute, the School of Visual Arts, and the Art Students League in New York City. Bill now resides in the Cape Cod village of Cotuit with his wife, Paulette, where he paints from his studio at home. Bill contributed an original painting to the charity auction at the Figawi Ball and for the 2000 program book cover. (Courtesy of the Figawi Archives.)

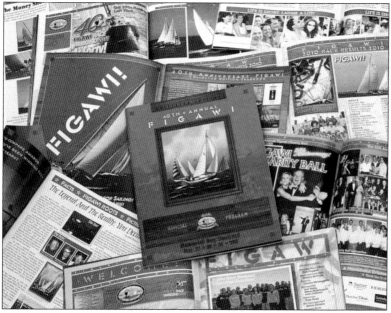

DESIGN AWARD FOR FIGAWI BOOK, 2012. The Figawi Board of Governors was informed in November 2012 that the 40th annual Figawi program book had received an American Graphic Design award from Graphic Design USA. (Courtesy of Bill Thauer.)

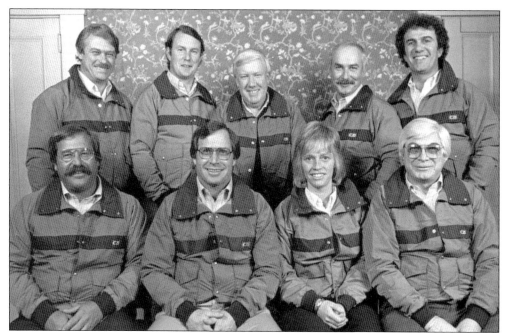

FIRST FIGAWI BOARD OF GOVERNORS, 1984. Pictured are, from left to right, (sitting) John Osmond, Joe Hoffman, Jacquie Newson, and Howard Penn; (standing) Fred Boden, Brian Olander, Dennis Sullivan, Fred Ellis, and Tony Prizzi. Members not included in this photograph are Fred Scudder and Bob Horan. (Courtesy of the Figawi Archives.)

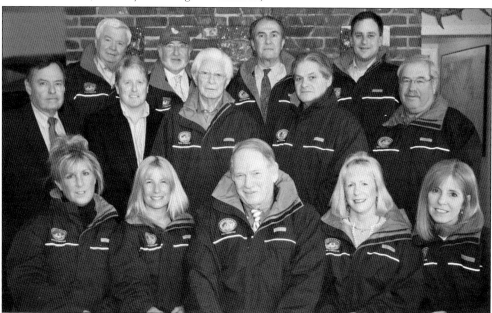

FIGAWI BOARD OF GOVERNORS, 2007. Pictured are, from left to right, (first row), Marie Boyd, Kim Hoffman, David Crawford, Judy Notz, and Donna Nightingale; (second row) Charlie McLaughlin, Nick Judson, Howard Penn, Milton Salazar, and John Osmond; (third row) Robert Haag, Leo Fein, Tony Prizzi, and Chris Standish. Members of the board missing from this photograph are Shelley McCabe, George Bassett, and John Stackpole. (Courtesy of the Figawi program book.)

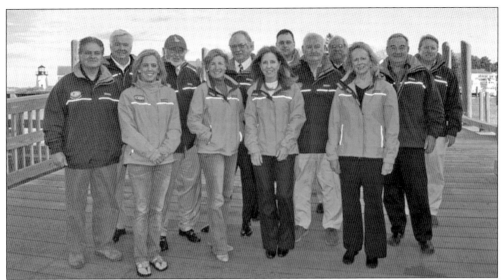

FIGAWI BOARD OF GOVERNORS, 2011. The women are, from left to right, Shelley McCabe, Kim Hoffman, Donna Nightingale, and Judy Notz. The men are, from left to right, Milton Salazar, Robert Haag, Leo Fein, David Crawford, Chris Standish, George Bassett, John Osmond, John Stackpole, and Nick Judson. Missing from the photograph are Charlie McLaughlin and Tony Prizzi. (Courtesy of the Figawi program book.)

THE FEINS RETIRE AND THE BOYS' SURPRISE, 2005. Leo and Susan Fein announced their retirement as co-chairs of the Figawi Ball, and as a special tribute and a well-deserved thank-you, the Figawi Board of Governors arranged for Mickey and Shaun Fein to come home from afar and celebrate with their parents. From left to right are Leo, Shaun, Susan, and Mickey. (Courtesy of Ed O'Neill.)

JACQUIE ON THE MICROPHONE, 2011. Jacquie Newson came onboard with Figawi in about 1977. She was working with Bob Horan in his real estate office in West Yarmouth and before long was an integral part of the Figawi Committee. Jacquie spent 12 years as the chairperson of the Figawi Board of Governors and still helps out Figawi whenever and wherever she can. (Courtesy of Britt Crosby.)

THE SILVER FOX AND BETTY. Howard and Betty Penn are seen here in the Figawi tent. Howard has been associated with Figawi since 1973. His contributions to this race were immense, and his contributions to everyone he knew were above-and-beyond. Howard passed away on March 17, 2012. (Courtesy of Britt Crosby.)

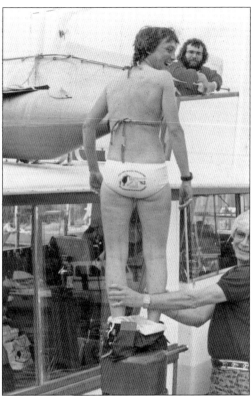

FIGAWI PANTIES, 1982. As the Figawi Race grew and expanded, so did its line of souvenirs. Here, Judy Fenner models a first in Figawi underwear, as Howard Penn steadies the model's stance on top of a dock piling. Looking the situation over from the other side of the boat is Neil Tomkinson, owner of *Chinook*. It turns out that the panties were not a big item at the souvenir table in 1982 and were discontinued in 1983. (Courtesy of the Figawi Archives.)

DAVID CRAWFORD WITH JOE HOFFMAN, 1984. Pictured on the right is the author of this book, Joe Hoffman. "What, David? You want me to write a *book* about Figawi?" (Courtesy of the Figawi Archives.)

Nine
Figawi Remembers

Since 1972, there have been lots of trophies awarded to many, many winners. Most have been for exceptional performance racing sailboats out on the ocean. But many have been to recognize and thank people for contributions that have made the Figawi Race what it is today.

What follows is the roll call of all the first-place sailors and a salute to the special trophy winners—along with a remembrance of those in the Figawi family who have died during the life of this event.

WINNERS OF THE ORIGINAL FIGAWI TROPHY, 1972–1986

1972
Red Rooster, Bob Luby

1973
Moby Dick, Stan Moore, captain, and
Ron Cameron, owner

1974
Division A: *Cheers*, Winthrop V. Wilbur Jr.
Division B: *Mooncusser*, John T. Griffin Jr.

1975
Class A: *Thorfinn*, John Osmond
Class B: *Cayenne*, J. Bentley
Class C: *Invincible*, John Linehan

1976
Class A: *Tuesday's Child*, Alan Small
Class B: *Starbuck*, John Ohrn
Class C: *Tarot*, Fletcher Street

1977
Class A: *Tuesday's Child*, Alan Small
Class B: *Adahara*, P. Walton
Class C: *More V*, R. Rozene
Class D: *Bow-Wow*, C. Robin
Streaker: *Nauti-buoy*, Richard W. Peckham

1978
Class A: *Thorfinn*, John Osmond
Class B: *Ariel*, D. Henderson
Class C: *Mitern*, O. Mclean
Class D: *Summer Salt*, S. Langford
Class E: *Sorceress*, F. Roone
Class F: *Independence*, C. McLaughlin
Streaker: *Gemini*, Dennis Sullivan

1979
Class A: *Tartan Ten*, Robert Walton
Class B: *Skysweeper*, R. Lenk
Class C: (unknown), A. Viekman
Class D: *Fellowship*, Tom Fellows
Class E: *Morpheus III*, Ben Walcott
Class F: (unknown), W. Stevens
Streaker: *Mavourneen*, Sally Serpico
Vintage: *Camelot*, Bob Labdon

1980
Class A: *Thorfinn*, John Osmond
Class B: *Loose Goose*, M. Frigard

Class C: *Flyway*, P. McEachron
Class D: *Tin Horn*, C. Gordon
Class E: *Reflexion*, P. Foraste
Class F: *Point After*, T. Tipton
Class G: *Morgheus II*, B. Walcott
Class H: *Noel*, H. Cahoon
Streaker: *Mavourneen*, S. Serpico

1981
Class A: *Destination*, B. Schofield
Class B: *Stanley Steamer*, S. Moore
Class C: *Sorceress*, F. Rooney
Class D: *Boomerang*, R. Baldwin
Class E: *Gypsy*, B. Shorrock
Class F: *Kahlua*, C. Hill
Class G: *Windancer*, F. Catania
Class H: *Luster*, W. Maloney
Streaker: *Gale E*, A. Hudson

1982
Class A: *Arieto*, B. Schofield
Class B: *Mr. Moose*, R. Horan
Class C: *Silver Streak*, J. Gallagher
Class D: *Hot Ruddered Bum*, D. Luke
Class E: *Second Chance*, S. Schweinshault
Class F: *Sensuous Turkey*, R. Hamlyn
Class K: *"R" Gang*, J. Ricciuti
Streaker: *Brace Yourself Bridget*, J. Foster

1983
Class A: *Wild Goose*, Wiley Wakeman
Class B: *Ragtime*, Peter Galvin
Class C: *Steal Away*, Joe Conway
Class D: *Tarot*, Fletcher Street
Class E: *Sorceress*, Frank Rooney
Class F: *Sensuous Turkey*, Russ Hamlyn
Class G: *Kahlua*, Curtis Hill
Class H: *Bow-Wow*, Colin Robin
Class K: *Deliverance*, TomLeach

1984
Class A: *Wai Aniwa*, Weston Adams
Class B: *Ms. BeHavin*, Bob Ferguson
Class C: *Loose Goose*, R. Mckenzie
Class D: *Scottish Ire*, Fred Scudder
Class E: *Independence*, C. Mclaughlin
Class F: *Quandy*, Bill Arnold
Class G: *Wanderer*, D. Rossini
Class H: *Fog Dog*, G. Seibert
Class K: *Mistral*, Charles Hume

Class L: *Deliverance*, Tom Leach
Class S: *Aviva*, Jerry Engel

1985
Class A: *Stanley Steamer*, Stan Moore
Class B: *Hawkeye*, Peter Johns
Class C: *Eclipse*, Phil Byrne and John Griffen
Class D: *Silver Streak*, Joe Gallagher
Class E: *Oliva*, John Wessmiller
Class F: *Absolutely*, Jim Carney
Class G: *Independent Fiddler*, Dick Paulus
Class H: *Cavale 1*, Fred Orr
Class K: *Agape*, Tom Hayes
Class L: *Vera*, longine Izbickis
Streaker: *Avanti*, Courtney McMahon

1986
Class A: *Matador*, William Koch
Class B: *Talaria*, George D'Arbeloff
Class C: *Spice*, Arthur Burke
Class D: *Assorted Nuts*, Carl Lindegren
Class E: *Chinook*, Neil Tomkinson
Class F: *Brisas*, Martin Scanlon
Class G: *Benvenuto*, Herb Borden
Class H: *Fellowship*, Tom Fallows
Class K: *Kahlua*, C. Hill and P. Lane
Class L: *Vetra*, Longine Izbickis
Streakers: *Turn-Er-About*, Douglas Turner

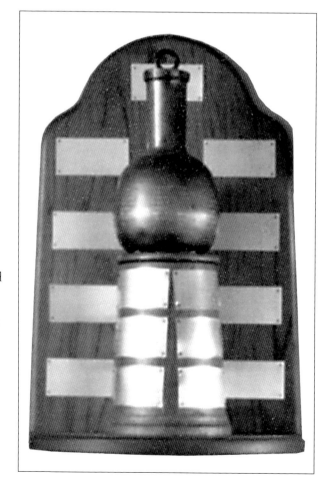

The founders of Figawi decided in 1973 that winners should be presented with a trophy. That year, Baxter's Boathouse presented a pewter wine decanter, which became the original grand prize of this event. The trophy was first presented to Stan Moore, skipper of the 1973 Figawi winner *Moby Dick*, owned by Ron Cameron. It was the tradition, in the early days, to toast the winner as he drank champagne from this decanter. The trophy is on permanent display at Baxter's on Pleasant Street in Hyannis. (Courtesy of Joe Hoffman.)

WINNERS OF THE PERMANENT FIGAWI TROPHY, 1987–2012

1987
Class A: *Matador*, William Koch
Class B: *Zip Code*, Rick Bishop
Class C: *Spice*, Arthur Burke
Class D: *Shockwave*, Chuck Howard
Class E: *Mat Black*, Barry Sturgis
Class F: *Defiance*, Robert Cicchetti
Class G: *Summers Off 2*, Slate/Tetreault
Class H: *Crisbelle*, Mavrick Giguere
Class K: *Fellowship*, Tom Fellows
Class L: *Morpheus II*, Benjamin Walcott
Streakers: *Adagio*, John Birmingham

1988
Class A: *Magic*, Marvin Rosen
Class B: *Wild Goose*, Wakeman/Laughlin
Class C: *Mogul Bandit*, Duggan/Bello
Class D: *Shockwave*, Chuck Howard
Class E: *Black Fin*, Barry Sturgis
Class F: *Counter Point*, John Holloway
Class G: *Defiance*, Robert Cicchetti
Class H: *Independent Fiddler*, Richard Paulus
Class K: *Cherokee*, Myron Sears
Class L: *Speculation*, Gregory Kelly
Streakers: *Bellatrix*, P. Gordon Nelson Jr.

1989
Class A: *Gambler*, John Downey
Class B: *Not By Bread*, Bill Donovan
Class C: *Moxie*, D.E. Adelberg
Class D: *Shockwave*, Chuck Howard
Class E: *Restless*, Bob Peterson
Class F: *Mya*, Edward Kennedy
Class G: *Defiance*, Robert Cicchetti
Class H: *Corisan*, Alexander Jenkins
Class K: *Helios*, Charles Prefontain
Class L: *Sloop Du Jour*, Peter Soule
Class S: *Celebration*, John Kells

1990
Class A: *Brigadoon VI*, Osmond/Morton/Harris
Class B: *Magic*, Marvin Rosen
Class C: *Mogul Bandit*, Tom Dugan
Class D: *Streaker*, Lan McNeice
Class E: *Black Fin*, Barry Sturgis
Class F: *Interloper*, Don McGraw
Class G: *Summer Off 2*, Tetreault/Slate
Class H: *Corisan*, Alexander Jenkins
Class K: *Benvenuto*, Herb Borden Jr.
Class L: *Sloop Du Jour*, Peter W. Soule

1991
Class A: *Capella VII*, Jim Stanley
Class B: *Wapatula*, Douglas Halstead
Class C: *Mogul Bandit*, Tom Duggan
Class D: *Shockwave*, Chuck Howard
Class E: *Black Fin*, Barry Sturgis
Class F: *Defiance*, Robert Cicchetti
Class G: *Sensuous Turkey*, Russ Hamlyn
Class H: *Cheshire*, Craig Ashworth
Class K: *Fellowship*, Thomas Fellows
Class L: *Helios*, Charles Prefontain

1992
Class A: *Valiant*, Gary Gregory
Class B: *Wapatula*, Douglas Halstead
Class C: *Fayal*, John Pinheiro
Class D: *Chinook*, Neil Tomkinson
Class E: *Hot Spur*, Phil DiCarlo
Class F: *Quandy*, William Arnold
Class G: *Corisan*, Oakley R. Jones
Class H: *Point After*, Bob Robertson
Class K: *Helios*, Charles Prefontain
Class L: *Crusader*, Sean Maher

1993
Class A: *Hooligan*, Peter Brinkerhoff
Class B: *Tern*, Robert Johnstone
Class C: *Zenda Flyer*, Barry Sturgis
Class D: *Mr. Bill*, Ian McNeice
Class E: *Dilligaf*, Russ Roth/Tom Mullen
Class F: *Defiance*, Robert Cicchetti
Class G: *Island Spirit*, Edward Phillips
Class H: *Camelot*, Robert Labdon
Class K: *Helios*, Charles Prefontaine
Class L: *Wings*, Robert Thomas

1994
Class A: *Banzai*, James Carney
Class B: *Zenda Flyer*, Barry Sturgis
Class C: *Nepenthe*, Robert Reed
Class D: *Kiwi*, Ian McNeice
Class E: *Arigato*, Bill Barron
Class F: *Defiance*, Robert Cicchetti
Class G: *Summers Off Two*, P. Tetreault/F. Silva
Class H: *Bodacious*, Lawrence Smoske
Class K: *Fellowship*, Thomas Fellows
Class L: *Windsong*, Todd Blazis
Class L: *Sloop Du Jour*, Peter W. Soule
Class M: *Heat Wave*, Bill Heaton
Class S: *Danger Zone*, Barry Sturgis Jr.

1995
Class A: *Weatherly*, George Hill
Class B: *Insatiable*, Bill Jones
Class C: *Affinity*, Jack Desmond
Class D: *Mon Keill*, Robert Cassity
Class E: *Wizard*, Chris Cooney/Henry Dane
Class F: *Team Sno-Search*, Bob Solomon
Class G: *Simpatico*, William F. Riley
Class H: *Bodacious*, Lawrence Smoske Jr.
Class K: *Glissade*, John O'Neil

1996
Class A: *Spice*, Arthur Burke
Class B: *Summer Song*, A. Kits VanHeyningen
Class C: *Streaker*, Halsey Herreshoff
Class D: *Nepenthe*, Robert Read
Class E: *Mr. Bill*, Ian McNeice
Class F: *Flying Goose*, Peter Goldstein
Class G: *Tabu*, Joseph O'Loughlin
Class H: *Mariann*, Brian Sager
Class K: *Moxie*, S. Dane Kimball
Class L: *Sloop Du Jour*, Peter W. Soule
Class M: *Pelican*, Ken Lawson
Class S: *Letter of Marque*, Douglas Halsted

1997
Class A: *Irie*, Brian Cunha
Class B: *Summer Song*, A. Kits VanHeyningen
Class C: *Fair Isle*, Curt Ivey
Class D: *Bluenose*, Scott Bearse
Class E: *Chinook*, Neil Tomkinson
Class F: *Flying Goose*, Peter Goldstein
Class G: *Equity*, Charles A. Murray
Class H: *J'erin*, James Flaherty
Class K: *Moxie*, S. Dane Kimball
Class L: *Sloop Du Jour*, Peter W. Soule
Class M: *Barefoot*, Chilton S. Cabot
Class S: *Letter of Marque*, Douglas Halsted
Class T: *Heritage*, Jeffrey Barrows

1998
Class A: *Spice*, Arthur Burke
Class B: *Affinity*, Jack Desmond
Class C: *Dreamer*, Jim Flanagan
Class D: *Nepenthe*, Robert Read
Class E: *Kiwi*, Ian McNeice
Class F: *Robert Emmett*, Richard Finnin
Class G: *Defiance*, Robert Cicchetti
Class H: *Camelot*, Robert Labdon
Class K: *Primrose*, Donald Liptack
Class L: *Isabel J.*, Andrew Keturakis
Class S: *Letter of Marque*, Douglas Halsted

Class T: *Heritage*, Jeffrey Barrows

1999
Class A: *Odin*, Ed Cusick
Class B: *Banzai*, James Carney
Class C: *Troll-Fjord*, W. Barrett Holby Jr.
Class D: *Chinook*, Neil Tomkinson
Class E: *Valkyrie*, Bruce T. Miller
Class F: *Shamrock*, Ralph DiMattia
Class G: *High Tension*, Wayne Meserve
Class H: *Dark Star*, Mark Gervais
Class K: *Ho Hum*, Wilkie Marvel
Class L: *Noeta*, Bob Ernest
Class M: *Bambino*, Halsey Herreshoff
Class N: *Helios*, Charles Prefontaine
Class S: *Letter of Marque*, Douglas Halsted
Class T: *Weatherly*, Bob Mathews

2000
Class A: *Amadeus*, Udo Schroff
Class B: *Affinity*, Jack Desmond
Class C: *Anthem*, Liz Mahon
Class D: *Infanta*, Brad Pease
Class E: *Faial*, John Pinheiro
Class F: *Makin Progress*, Ryan Walsh
Class G: *In Deep*, Bob Warren
Class H: *Defiance*, Robert Cicchetti
Class K: *Mariann*, Brian Sager
Class L: *Camelot*, Robert Labdon
Class M: *Scallywag*, Mark Hamlyn
Class N: *Helios*, Charles Prefontaine
Class S: *Troll-Fjord*, W. Barrett Holby Jr.
Class T: *Intrepid*, Joseph P. McParland

2001
Class A: *Spice*, Arthur Burke
Class B: *Affinity*, Jack Desmond
Class C: *Southern Dream*, Jim Flanagan
Class D: *Wizard*, K. Anderson/H. Dane
Class E: *Faial*, John Pinheiro
Class F: *High Tension*, Wayne Meserve
Class G: *Osprey*, Tom Hutchinson
Class H: *Siren*, Peter Cassidy
Class K: *Trilogy*, Donald Scheller
Class L: *Secret*, Gerry Panuczak
Class M: *Helios*, Charles Prefontaine
Class N: *Isabel J.*, Andrew Keturakis
Class T: *American Eagle*, Tom Johnson

2002
Class A: *Midnightsun*, Howard Eisenberg
Class B: *Maji Moto*, Scott Bender

Class C: *Escape Pod*, Morris Hinckley
Class D: *Infanta*, Brad Pease
Class E: *Dreamcatcher*, Stephen Kylander
Class F: *Makin Progress*, Ryan Walsh
Class G: *Equity*, Charles Murray
Class H: *Bryemere II*, Brian O'Neill
Class K: *Nicola*, Gene Monteiro
Class L: *Bambino*, Halsey Herreshoff
Class M: *Saylavee*, Peter Soule
Class N: *Swag*, Bruce Benson
Class T: *Weatherly*, Robert Matthews

2003
Class A: *Revolution VI*, Jim and Doyle Marchant
Class B: *Havoc*, Sanford Tyler
Class C: *Tabu*, Joseph O'loughlin
Class D: *Infanta*, Hywel Madoc-Jones
Class E: *Riptide*, Gordon Fletcher
Class F: *Robert Emmett*, Rick E. Finnin
Class G: *In Deep*, Bob Warren
Class H: *Defiance*, Robert Cicchetti
Class K: *Camelot*, Bob Labdon
Class L: *Swiftsure*, Michael Parker
Class M: *Spray*, Jason Calianos
Class N: *Cassiopeia*, Evan McCormick
Class T: *General Quarters*, J.C. Raby

2004
Class A: *Sforzando*, Blair Brown
Class B: *Xenophon*, Jeff Rabuffo
Class C: *Moondog*, Thomas E. Purcell, MD
Class D: *Allaura*, Bill Abbott
Class E: *Flashpoint*, John Mollicone
Class F: *In Deep*, Bob Warren
Class G: *Chloe Nicole*, Thomas Hall
Class H: *Facet*, Tom Tetrault
Class K: *Blue Note*, Paul Blum
Class L: *Saylavee*, Peter Soule
Class M: *Primrose*, DonaldLiptack
Class N: *Helios*, Charles Prefontaine
Class T: *No Decorum*, JC Raby

2005
Class A: *Chippewa*, Clayton Deutsch
Class B: *Xenophon*, Jeff Rabuffo
Class C: *Southern Dream*, James Flanagan
Class D: *Siren*, Peter Cassidy
Class E: *Top Cat*, Thomas Lyons
Class F: *Makin' Progress*, Stan Walsh
Class G: *In Deep*, Bob Warren
Class H: *Defiance*, Robert Cicchetti
Class J: *Shamrock IV*, Thomas Mullin

Class K: *Facet*, Tom Tetrault
Class L: *Camelot*, Bob Labdon
Class M: *Seannine*, Patrick O'Leary
Class N: *Helios*, Charles Prefontaine
Class S: *Samba*, Phillip Garland
Class T: *American Eagle*, Marshall Peterson

2006
Class A: *Chippewa*, Clayton Deutsch
Class B: *No Quarter*, Chris Owen
Class C: *Dark Star*, Mark Gervais
Class D: *Ole*, Richard Blatterman
Class E: *Coconut*, Tom D'Albora
Class F: *In Deep*, Bob Warren
Class G: *Courtship*, Charlie Peck
Class H: *Leaf*, Dan Regan
Class K: *Vela*, Richard Bermudez
Class L: *Facet*, Tom Tetrault
Class S: *Aquarius*, Sam Fleet
Class T: *Weatherly*, Mox Tan

2007
Class A: *Affinity*, Jon Desmond
Class B: *Southern Dream*, Jim Flanagan
Class C: *Allaura*, Bill Abbott
Class D: *Siren*, Peter Cassidy
Class E: *Fortune*, Don Glassie
Class F: *Rugosa*, Halsey Herreshoff
Class G: *Indian Summer*, Sheridan Casey
Class H: *Simpatico*, Bill Riley
Class K: *Satinka*, Scott Beliveau
Class L: *Facet*, Tom Tetrault
Class M: *Helious*, Charles Prefontaine
Class N: *White Swan*, Scott Shucher
Class S: *Dark 'n' Stormy*, Eric Wagner

2008
Class A: *Gambler*, John Downey
Class B: *Equus*, Jeremy Pochma
Class D: *Wizard*, Bill Scatchard
Class E: *Sequoia*, Ted Severance
Class F: *Legacy II*, Tom Denney
Class G: *Ultraviolet*, Matt Rosenberg
Class H: *Shindig*, Kevin Flannery
Class K: *Karma*, Kevin Rocha
Class L: *Club Car*, Barry Bessette
Class M: *Sapphire*, Dimitrios Salemis
Class N: *Spray*, Jason Calianos
Class S: *Wazimo*, Bob Manchester
Class S2: *Straight Jacket*, Sanford Tyler

2009
Class A: *Vanish*, William Jacobson
Class B: *Slide Rule*, Scott Bearse
Class C: *Southern Dream*, Jim Flanagan
Class D: *Zingara*, Chris Magee
Class E: *Wizard*, Bill Scatchard
Class F: *Eider Down*, Bruce Robinson
Class G: *Perfect Summer*, Bob Solomon
Class H: *Paradise*, Bud Harris
Class K: *Defiance*, Robert Cicchetti
Class L: *Kayla*, Mark Selvaggi
Class M: *Swiftsure*, Michael Parker
Class N: *Dolphin*, Paul Murphy
Class 5: *Cutlass*, Alex Mehran/Nick H.

2010
Class A: *Denali*, Michael Damelio
Class B: *Equus*, Jeremy Pochman
Class C: *Southern Dream*, Jim Flanagan
Class D: *Tabu*, Joseph O'Loughlin
Class E: *Eider Down*, Bruce Robinson
Class F: *Great Day*, Robert Giodano
Class G: *Imagine*, Brett Berkley
Class H: *Summer Dreams*, Fred Mesinger
Class K: *Nepenthe*, Marc Fater
Class L: *Freya*, Fred Trezise
Class M: *Secret*, Gerry Panuczak
Class N: *Helios*, Charles Prefontaine
Class 5: *Vixen*, Christopher Beane

2011
Class A: *Natalie J*, Mass Maritime Academy
Class B: *Slide Rule*, Scott Bearse
Class C: No finishers due to weather
Class D: No finishers due to weather
Class E: *Wildflower*, JJ Pope
Class F: No finishers due to weather
Class G: No finishers due to weather
Class H: No finishers due to weather
Class K: No finishers due to weather
Class L: No finishers due to weather
Class M: No finishers due to weather
Class N: No finishers due to weather
Class 5: *Bronco*, Thomas Loughboro

2012
Class A: *Kinship*, Ryan Walsh
Class B: *Mustang*, Harvey Jones
Class C: *Seefest*, Ira Perry
Class D: *Wizard*, William Scatchard
Class E: *Lynley III*, Jim Barnes
Class F: *Destiny*, Andrew Davis
Class G: *Rendezvous II*, Michael Mason
Class H: *Alquemie*, Marc Bucklen
Class K: *Simpatico*, Bill Riley
Class L: *Club Car*, Barry Bessette
Class M: *Secret*, Gerry Panuczak
Class N: *Helios*, Charles Prefontaine
Class 51: *Wicked 2.0*, Douglas Curtiss
Class 52: *Dark 'n' Stormy*, Andrew Reservitz

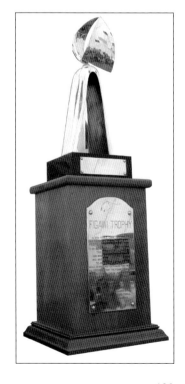

INSCRIPTION ON THE PERMANENT FIGAWI TROPHY. "In 1972, three Cape Cod sailors, Bob and Joe Horan, along with Bob Luby, raced from Hyannis to Nantucket to decide who owned the fastest sailboat. The following summer, Bob Horan organized the event and invited other Cape sailors to join in the challenge. While searching for a name for the race, he determined that the Figawi Indian tribe used to sail these same waters. When they were lost in the inevitable fog on Nantucket Sound, the cry could be heard across the water: 'Where the Figawi?' This trophy is now shared by all who have enjoyed the thrill of being a Figawi winner." (Courtesy of Britt Crosby.)

Cape Cod Marine Trades Association Trophy Racing (R) and Cruising (C) Divisions, 1983–2012

1983: Joe Conway, *Steal Away*
1984: Bob Ferguson, *Ms. Behavin*
1985: Stan Moore, *Stanley Steamer*
1986: Tom Fellows, *Fellowship* and Neil Tomkinson, *Chinook*
1987: Mass Maritime, *Eighty-Six*
1988: Tom Duggan and Mike Bello, *Mogul Bandit*
1989: John Downey, *Gambler*
1990: R: Barry Sturgis, *Black Fin*
 C: Don McGraw, *Interloper*
1991: R: Tom Duggan, *Mogul Bandit*
 C: Craig Ashworth, *Cheshire*
1992: R: Neil Tomkinson, *Chinook*
 C: Oakley R. Jones, *Corisan*
1993: R: Barry Sturgis, *Zenda Flyer*
 C: Michael Deely, *Bambino*
1994: R: James Carney, *Banzai*
 C: Tom Fellows, *Fellowship*
1995: R: Chris Cooney/Henry Dane, *Wizard*
 C: Peter Soule, *Sloop Du Jour*
1996: R: Tom and Beth Duggan, *Mogul Bandit*
 C: Joseph O'loughlin, *Tabu*
1997: R: Neil Tomkinson, *Chinook*
1998: R: Joe O'Neal, *Banshee*
 C: Donald Liptack, *Primrose*
1999: R: Ed Cusick, *Odin*
 C: Mark Hamlyn, *Scallywag*
2000: R: J. Brad Pease, *Infanta*
 C: B.B. Hredocik, *Cool Runnings*
2001: R: Karl Anderson, *Wizard*
 C: Gerry Panuczak, *Secret*
2003: R: Hywel Madoc-Jones, *Infanta*
 C: Bob Labdon, *Camelot*
2010: R: Fred Mesinger, *Summer Dreams*
 C: Jeremy Pochman, *Equus*
2011: R: Mass Maritime Academy, *Natalie J*
 C: No winner due to weather
2012: R: Harvey Jones, *Mustang*
 C: Barry Bessette, *Club Car*

Howard K. Penn Spirit Award Trophy Winners, 2010–2012

2010: Mariette Vigeant
2011: Mike Mason
2012: Steve Woolfson

Jeffrey Carter Foster Team Trophy Winners, 1995–2012

1995: *Twenty Hundred Club* of *Narragansett Bay*, D'Albora, Read, and Bioty
1996: *Mattapoisett Yacht Club*
1997: *Nantucket Yacht Club*, McNeice, Goldstein, and Halsted
1998: *Nantucket Yacht Club*, McNeice, Goldstein, and Halsted
1999: *Cape Cod 3 Team*, Carney, Tomkinson, and Robertson
2000: *Buzzards*, Burke, Pinheiro, and Walsh
2001: *Buzzards*, Burke, Pinheiro, and Walsh
2002: *Woody*, BB Hredocik, Labdon, and Pease
2003: *Wicked Pissa*, Raby/Hinckley, Marchant, and Waldren
2004: *Mattapoisett Yacht Club* 1, Warren, Prefontaine, and Downey
2005: *Better Than You*, Desmond, Cassidy, and Cicchetti
2006: *Fiery Dark Coconuts*, Grossman, Gervais, and D'Albora
2007: *The Gang*, Abbott, Marsh and Bartlett
2009: *Over The Hill Gang*, Bearse, Marsh, and Abbott
2010: *Mattapoisett Yacht Club*, Prefontaine, Warren, and Prefontaine
2011: *Buzzards*, Walsh, Kylander, and Perry
2012: *Team Chatham*, Bush, Panuczak, and Riley

High School Invitational Regatta Winners, 2000–2012

2000: Belmont Hill
2001: Harwich
2002: Martha's Vineyard
2003: Dartmouth
2004: Dartmouth
2005: Chatham
2006: Barnstable
2007: Barnstable
2008: Nauset Regional
2009: Bishop Stang
2010: Dartmouth
2011: Nauset Regional
2012: Barnstable

The Pamela Trussell Duggan Trophy Special Recognition Awards, 1989–2012

1989: Jacquie Newson and Howard Penn
1990: John C. Linehan
1991: Robert "Red" Luby
1992: Roger Newson
1993: Frank Bearse
1994: Ellyn Osmond
1995: Judy Notz
1996: Dennis Sullivan
1997: Marie Boyd
1998: Debbie Newson
1999: Susan and Leo Fein
2000: Carl L. Flipp
2001: Bob Adomunes
2002: Shelley McCabe
2003: Milton Salazar
2004: Edward O'Neill
2005: J. David Crawford
2006: Tom Duggan
2007: Keith Sexton
2008: Donna Nightingale
2009: Chris Standish
2010: Ellen Zavatsky
2011: Lorraine Levine
2012: Britt Crosby

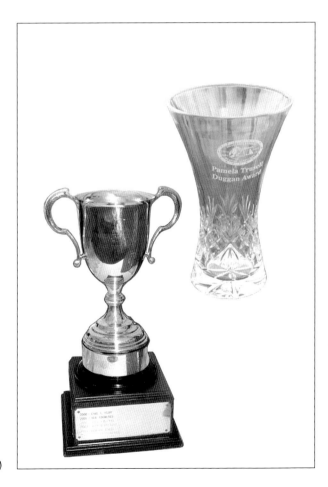

This trophy was created in memory of Pamela Trussell Duggan, a member of the Figawi Board of Governors and a friend to everyone she met. Her untimely passing in February 1989 is still felt by all who knew her. The trophy is presented to an individual who has demonstrated an outstanding contribution to the Figawi Race and is inscribed as follows: "In memory of Pamela Trussell Duggan, May 7, 1958–February 14, 1989." The crystal "keeper" trophy (upper right) is presented to the winner each year during the Figawi awards ceremony. (Courtesy of the Figawi Archives.)

Figawi remembers those who have gone...

1989
Pamela Trussell Duggan

1995
Al Bluestein
John Scott

1996
Ron Carr
Thomas Vincent "Vinny" Gildea
Robert W. "Red" Luby

1997
Jeffrey Carter Foster

2000
Warren Thatcher "Barney" Baxter, Jr.
Richard C. Anderson

2001
John T. "Jack" Fallon

2002
Jamie Boeckel

2003
Alexandra Nicole Zapp

2004
John C. Linehan
Frank B. Bearse

2005
Joseph Horan

2006
Robert F. Horan

2009
Edward M. Kennedy

2011
Dianna L. Panesis
James Summers "Scotty" Peatie
Fred Boden
Edwin A. "Win" Carter

2012
Howard K. Penn

2013
Edward E. O'Neill

Discover Thousands of Local History Books Featuring Millions of Vintage Images

Arcadia Publishing, the leading local history publisher in the United States, is committed to making history accessible and meaningful through publishing books that celebrate and preserve the heritage of America's people and places.

Find more books like this at
www.arcadiapublishing.com

Search for your hometown history, your old stomping grounds, and even your favorite sports team.

Consistent with our mission to preserve history on a local level, this book was printed in South Carolina on American-made paper and manufactured entirely in the United States. Products carrying the accredited Forest Stewardship Council (FSC) label are printed on 100 percent FSC-certified paper.